How to photograph
Weddings, Groups & Ceremonies

Tom Burk

Executive Editor: Carl Shipman
Editor: Theodore DiSante
Art Director: Don Burton
Book Design & Assembly: Ken Heiden
Typography: Cindy Coatsworth, Joanne Nociti, Michelle Claridge
Photography: Tom Burk, unless otherwise credited

Published by H.P. Books, P.O. Box 5367, Tucson, AZ 85703 602/888-2150
ISBN: O-89586-O57-O Library of Congress Catalog Card No. 8O-83275
©198O Fisher Publishing, Inc. Printed in U.S.A.

Contents

Introduction

It seems that in today's world everyone and everything must fit into some category or another. Let's begin by finding the category you fit, and see how this book will help you.

CATEGORY I: You have been interested in photography for some time and have managed to create some nice work that you share with friends and relatives. Everyone has recognized his or her own face in the pictures, and you've even captured some good expressions from time to time. This makes your photography emotionally rewarding and sometimes financially rewarding, too.

As it happens, Cousin Zelda is getting married next month, and when wedding photographs were discussed, your name popped into Aunt Eunice's mind. Here's an opportunity to do a favor for your dear cousin and, at the same time, broaden your photographic skills as well. Naturally, you accept the honor.

During the week prior to the ceremony, you receive a processed roll of film from the photofinisher and discover that you exposed it at the wrong sync speed for your electronic flash. Not one frame on the roll is printable. It's a rather gross error and it could happen at the wedding. Your confidence is sagging.

CATEGORY II: You're much the same person as in Category I, with an important exception. You didn't waste a roll of film before Zelda's big day, and you did the job with plenty of confidence. You've now received the processed film and proof prints from the photofinisher and have delivered them to the happy couple for their selection for enlargements. It was fun doing the wedding, and you want to try another.

CATEGORY III: You're a professional photographer and have been for some time. You've photographed more weddings and groups then you care to recall but, like me, you're a book nut. You believe you've never read one that didn't benefit you in some way.

If you are in any of these categories—or even an outright begin-

The wedding day is traditionally the bride's day.

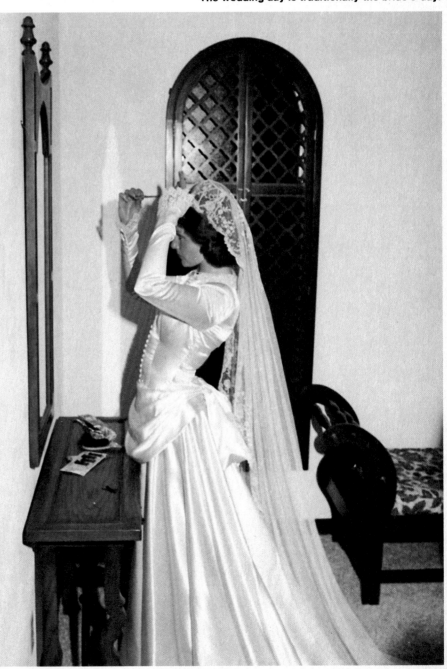

ner—this book will help you. It is one of the few you'll find written from a relatively negative point of view. There are more *don'ts* than *do's*. Whether amateur or professional, any photographer unaware of the *don'ts* of wedding photography can easily become *persona non grata*.

This negative point of view is in no way intended to dissuade you from wedding and group photography, but rather to alert you to the pitfalls and show you how to circumvent them. Good photographs combined with good behavior and service will make you socially popular, can be highly profitable, and will be a source of pride for years to come.

Although each wedding or group requires a certain percentage of standard photographs, each event is as different as its participants. I can't possibly enumerate all variations, so I'll concentrate on showing you how to plan shots that are appropriate to the particular event.

My purpose is to help you through the activities as painlessly as possible, from the time you are asked to participate, through the day the finished prints are delivered.

Like many how-to books, this book will be criticized by some as an effort to undercut or ease out the working professional photographer. That is not so. The fact is that I'm a professional photographer who has learned that when the quality of my work is as it should be, I have no fear of losing business to those who might undercut my prices. Any business that might go to someone else because of price or friendship would not be mine under any circumstances anyway.

You will not automatically turn into a professional merely by reading this book anymore than you will through the acquisition of an expensive camera. However, if you aspire to the level of a professional, reading this book, along with serious thought and practice, will help get you through what can be a traumatic experience and move you a step nearer your goal.

Together, we will move step-by-step. Because weddings are photographed most often and are the most demanding of your skill, I'll begin there. Tips on photographing other ceremonies and groups follow.

If you are the old pro, you'll find little if anything new, but each of us needs to periodically return to basics and reassess our direction. Take a few moments and re-examine the ceremonial tradition. It has changed so little with time that the changes, if any, are almost imperceptible. The basics of yesterday are the basics of today.

But she is not the only one who is excited. It's a big day for everyone, including you. Pictures such as these open the way for extra print sales and show that you've done a complete job.

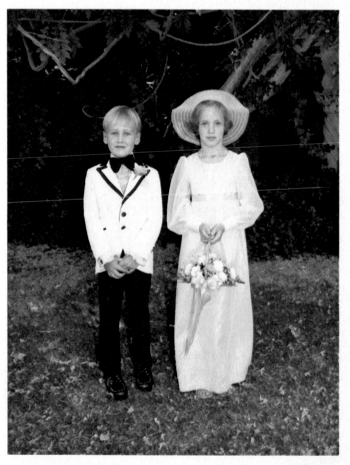

1 Equipment

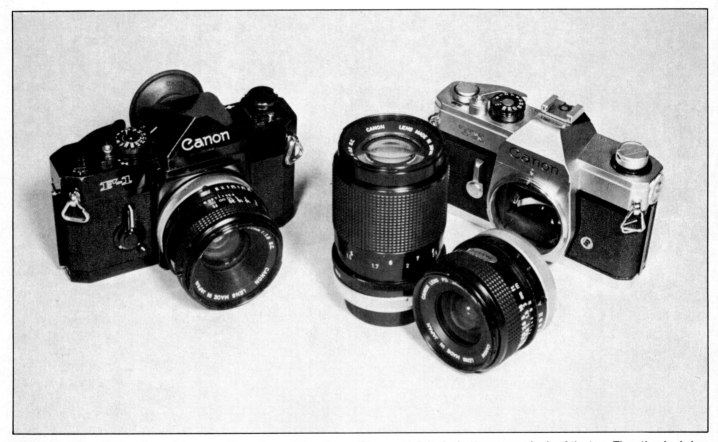

This is the 35mm SLR equipment I use most to make wedding photos. Shown at left is the better camera body of the two. The other body is a less expensive model of the same brand that will also accept the wide-angle, standard, and telephoto lenses shown.

You should be thoroughly familiar with the equipment you use for photography. A wedding is no place to try out new hardware or film materials. If you have finally saved enough to buy your new dream camera, don't make the purchase the day of the wedding and plan on learning how to use it at the ceremony. Leave it home and use the older equipment you're familiar with at least one more time. Save the new camera for weekend photographs when you can test it more leisurely. Ninety-nine percent of the cameras on the dealer's shelf are perfectly reliable, but it's possible that your luck will direct you to one with a serious defect. Don't find that out at the expense of the bride's pictures and your photographic reputation.

Regardless of how familiar you are with your camera, things can still go awry, and they often will. If it is possible, pack an additional camera as a backup to be safe. Many a photographer's sanity and reputation have been saved by the availability of a second camera. It is well worth having, even though you may never use it.

If you don't already have a second camera, give serious thought to buying only a second body. Choose one that will accept the lenses you already have for your first-line equipment. You can

probably do quite well with a less expensive model of the same brand, though it may lack some of the extra capability that impressed you when you made your original purchase. Depending on your financial situation, you may wish to buy the same type of body you have been using. Remember that the higher priced model still offers a considerable cost saving over the price of another camera and lens of a different brand.

The above discussion is mainly for 35mm SLR users. If you prefer and have been accustomed to larger-format equipment, you are aware that an additional body can be quite expensive. In this case, I suggest you drop your standards a bit and use one of the less expensive 35mm SLR camera systems as backup equipment. To be a photographic purist who desires the best image quality through the use of larger format is a commendable practice; however, when equipment fails, some pictures are better than no pictures at all.

THE CAMERA

There is a wide choice of cameras and a great difference of opinion as to the merits of any particular brand. But without doubt, the most popular cameras today are 35mm SLR cameras. They are often used for weddings, as well as other events, from group portraiture to barn-burnings.

This equipment is operationally fast, easy to carry, has a wide lens selection, and offers the greatest number of exposures per film load. Additionally, 35mm SLR cameras are usually less expensive than large- or medium-format cameras and equipment.

Even though I recommend 35mm SLR equipment, I'll discuss some of the other types available, ranging from the tiny 110 to the old standby, 4x5. Each has its rightful place in the photographic scheme of things.

The 110 Camera—These cameras have gained wide acceptance among weekend and vacation snapshooters. Certainly, few cameras are as easy to carry as these tiny machines, some of which have surprising sophistication. They offer rapid film loading, point-and-shoot exposure, automatic light metering, and synchronized electronic flash. Some have zoom lenses and others have interchangeable lenses.

This is a nifty assortment of features in a tiny package, but all the advantages are countered by the small negative it produces. In my opinion image quality suffers greatly in enlargments bigger than 5x7. Of course we've all seen enlargements greater than 5x7 made from 110 negatives and some are of marginally acceptable quality. However, not every 110 negative produces the quality exhibited in these advertisements.

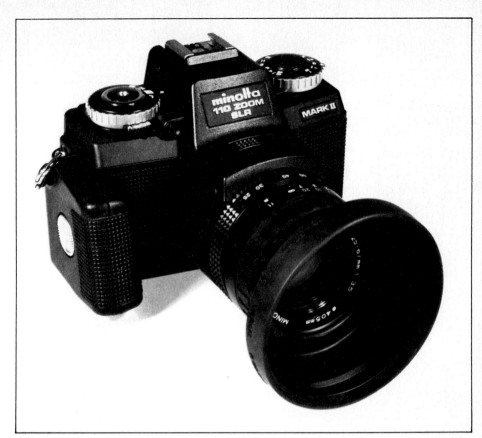

The latest generation of 110 cameras is very sophisticated. The Minolta Mark II camera shown here has aperture-preferred automatic-exposure, a zoom lens with close-focusing, reflex viewing, and other features that make it seem like a miniature 35mm SLR camera.

Because it yields a small image, as shown here, I don't recommend a 110 camera for wedding or group photography.

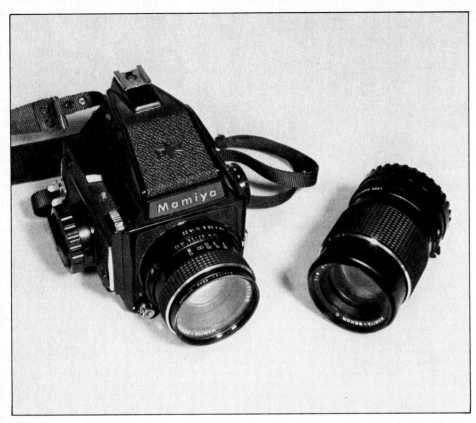

This Mamiya M645 medium-format SLR produces 15 images per roll of 120 film. Each frame is 4.5x6 cm. Shown here are the standard 80mm lens and a longer-focal-length lens that I use for the formal bridal portraits.

4.5x6 cm Image

The 4.5x6 cm image is slightly smaller than the traditional 6x6 cm (2-1/4-inch-square) image. One advantage is that you can get 15 and 30 exposures per roll of 120 and 220, instead of only 12 and 24 as with the 6x6 cm format. In addition, you can make either horizontal- or vertical-format photos.

Medium-Format Cameras—This class of cameras can produce several image formats, from 4.5x4.5 cm to 6x7 cm. The cameras differ in size and shape, depending on whether they are SLRs or TLRs.

Medium-format cameras using two lenses are called twin-lens reflexes (TLR). These are less expensive than SLR medium-format cameras, but generally, they are slower to use and offer fewer accessories as part of their system. Both kinds use 120 film.

The advantage these cameras offer is a large image, allowing greater enlargement with less magnification relative to a 35mm frame. The disadvantages are the higher price, fewer exposures per roll and, of course, total weight.

Based on these factors, I do not recommend cameras that use 120 film as the best choice for the candid scenes of weddings. I do, however, recommend the cameras for scenes that allow you to use a tripod and the necessary time for posing. This is especially helpful when dealing with a group or making the bride's formal portrait.

Because the medium-format image is big, lenses that give the same amount of coverage as lenses for a 35mm camera are also bigger. Typically, a standard medium-format lens is between 70 and 80mm. Wide-angle lenses are shorter than 70mm, and telephoto lenses are longer than 80mm.

Few photographers use a 4x5 camera for wedding work today because of its large size and the difficulties of working quickly with sheet film and film holders. Shown here are the Crown Graphic 4x5 press camera—which is no longer made—film holders, and a roll-film back that holds 120 film.

In spite of its problems, the 4x5 camera does give a large image that is great for group photography. The photo below is the same size as a standard piece of 4x5 sheet film. Photo by Steven A. Sint for Glenmar Photographers.

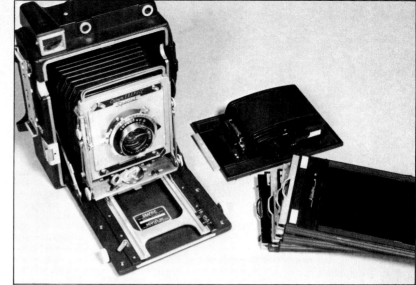

The 4x5 Camera—The 4x5 camera was the workhorse of the wedding and group photographer for many years, and in some cases it is still useful. The excellent mechanics, electronics and optics of modern, smaller format cameras have relegated the 4x5 camera to situations not requiring fast handling and portability, such as some group photography.

The advantage of this format is the size of the negative—approximately four inches by five inches. The enlarging and retouching capabilities are quite impressive. There is an additional minor advantage. These cameras are no more expensive than most medium-format SLR cameras.

Although these are important advantages, the disadvantages are more important. The cameras are bulky, unwieldy and operationally slow. Lenses are very large and expensive. The standard lens for a 4x5 camera has a focal length of about 135mm.

The 4x5 sheet film must be loaded in the darkroom into holders that accept only one sheet on each side. Therefore, 100 exposures require 50 film holders, which is formidable in both weight and cost. With the addition of the camera, flash, tripod, cases, meter and assorted cables and connectors, transporting equipment becomes quite a task.

4x5 Image

INTERCHANGEABLE LENSES

Just as when choosing a camera, choosing one or more lenses is a matter of individual preference. However, some photographs are best made with particular lenses. I'll discuss a few of the most useful lenses for wedding photography with a 35mm SLR, starting with wide angles and finishing with zooms.

28mm — Perhaps the most reasonable lens to begin with, although I'm reluctant to do so, is the 28mm. My feeling is based on the fact that this lens is usually considered the most useful wide-angle lens. Actually that use is more commonly abused than not.

The beauty of the wide-angle lens is that it sees a great portion of a scene from a very short distance. The problem is that it also distorts the size and shape of objects in the scene, especially objects near the edge of the frame. Such distortion is generally not apparent in photos of landscapes, but pictures of people will not fare nearly as well. Faces and bodies are stretched and look fatter than they really are. The distortion of this lens can cause considerable distress to the people so affected in the group photograph.

I suggest you resist the temptation to use the 28mm lens for wedding photography unless you're extremely knowledgeable in the best way to use it. I list it here because it is becoming common as part of a package offered by many camera dealers. If you already have it, save it for scenic views.

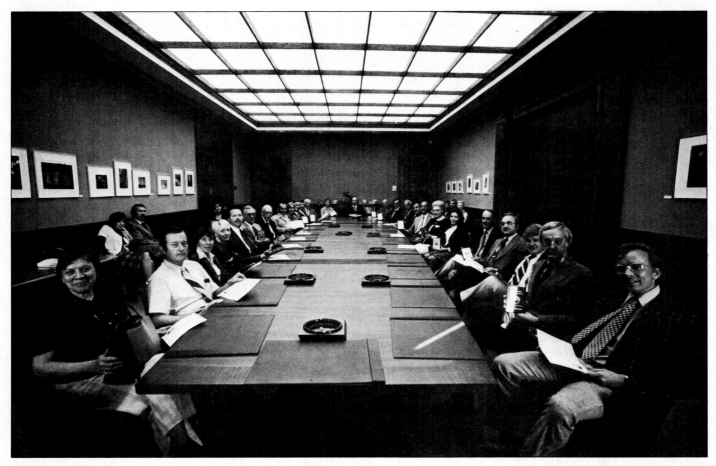

This group photo was made by George Kew with a 20mm lens. Notice how the lens distorted the two people nearest the lens.

HOW MANY LENSES?

Give considerable thought to your lens choice. Don't become overzealous and make the selection too large. Purchase only the lenses you sincerely believe you must have to do the work you are engaged in.

It takes time to retrieve a lens from a carrying case, remove the camera lens, attach the new lens, and deposit the other one in its case. That's time you may not have.

Even under ideal conditions, there are phases of the wedding when you will have little time to stay with the ceremony, while making changes in nothing more than focus.

35mm—When I photograph weddings with 35mm SLR equipment, the 35mm wide-angle lens is by far my favorite. Very often, you will find yourself in tight spaces at the wedding. For instance, the bride's dressing room and the groom's waiting room are almost always exceedingly small and cluttered. Space in which to move is at a premium. The relatively short focal length of the 35mm lens allows a short camera-to-subject distance, while retaining the overall field of view you need.

You can photograph group arrangements following the ceremony and at the reception at a relatively short distance, which makes it easier to communicate and give directions. This is of real importance when the wedding is large and people are spread across a large area. The close distance also reduces the risk of someone standing up in front of you at the instant you release the shutter.

Compared to standard 50mm lenses, wide-angle lenses also provide greater depth of field at a given distance and aperture. This helps a bit in obtaining sharp images on the negatives.

However, don't be lulled into thinking that by using a 35mm you have eliminated the problem of distortion. At best, you have only reduced the possibility. Thought, care and knowledge of your equipment is still absolutely essential to avoid portraying your subject in an unfavorable manner.

I recommend the 35mm lens for photographing in small rooms, such as the bride's dressing room. You can also use it for photos of the groom and best man before the ceremony, signing of the license, and for some group photography.

A moderate telephoto lens, such as a 100mm lens for a 35mm SLR, is ideal for a portrait like this one. Photo by Diane Ensign-Caughey.

I think a fast, standard lens is ideal for the long-exposure photos you'll make during the ceremony. Photo by Diane Ensign-Caughey.

The Standard Lens—The standard lens is the lens that most closely approximates the subject as seen by the human eye. With the 35mm SLR camera, the standard lens is in the range of 45mm to 55mm. Surprisingly, it is capable of fulfilling all photographic requirements prior to, during, and following the wedding ceremony.

The Telephoto Lens—For our purposes, lenses with a focal length exceeding 100mm or 105mm are seldom used. Situations demanding the use of a lens with a longer focal length are:

**The bride's formal portrait.
The bride alone prior to or
following the ceremony.
The bride and groom,
three-quarter view.
One or two settings at
the reception.**

You may find it desirable to use a telephoto lens for long-exposure photos of the wedding ceremony; however, I have always preferred the standard lens for such photographs because I am able to include a portion of the room and a number of guests. If you are working in an especially beautiful room you should not exclude the surroundings through the use of a long lens.

The primary problem encountered when using the long lens is space in which to work. As I mentioned already, most dressing and waiting rooms are very small and a telephoto lens requires that you have enough space for a long camera-to-subject distance. The space factor is also an obvious handicap when attempting group arrangements.

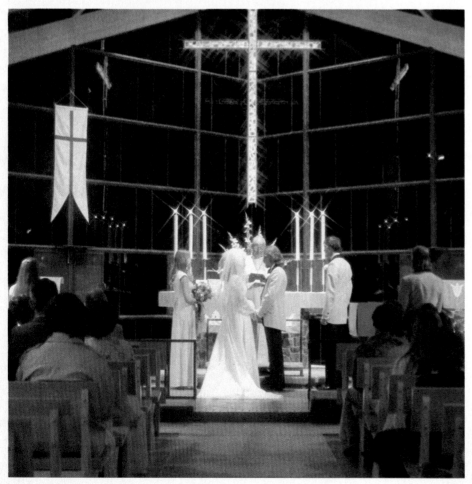

Zoom Lenses—The advantage of the zoom lens is its ability to operate over a great range of focal lengths, allowing you to alter composition and image size without having to change viewpoint. A zoom lens can eliminate the necessity of acquiring several different lenses of fixed focal length. These lenses are available in many ranges, such as the relatively short range Nikon 43-86mm lens, to the longer Vivitar Series I 70-210mm lens.

The disadvantages are that zoom lenses are relatively expensive, generally heavier than the fixed focal length lenses, and may not be satisfactorily sharp over the entire zoom range.

Some of the least expensive ones are not aperture corrected, which means that you must adjust the aperture when you change the lens from minimum to maximum focal length. This feature is a disadvantage when you use an automatic electronic flash.

A zoom lens in the right focal-length range is a handy tool. The Nikon 43mm-86mm lens works well for me because the focal-length range goes from slightly wide-angle to moderate telephoto. You can also get wide-angle and telephoto zooms.

Zoom lenses let you make different compositions from one position without the bother of changing lenses. The ability to crop in the viewfinder and make tight compositions will eliminate the need for cropping the negative later. Photos by Diane Ensign-Caughey.

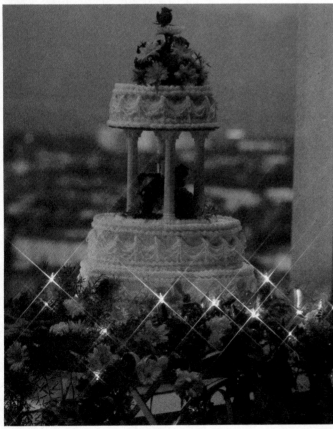

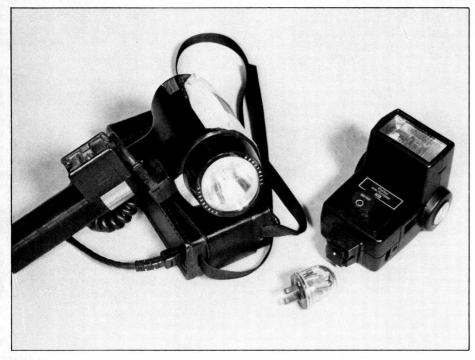

This is my standard flash equipment. The small flash on the right is the Vivitar 283 automatic flash. I use it on camera for nearly all candid pictures. The flash on the left is a more powerful manual flash that I use as the main light in a two-light setup described in the text. The plastic "bubble" between the two flashes is a slave cell that attaches to the main flash when I use it in a two-light setup.

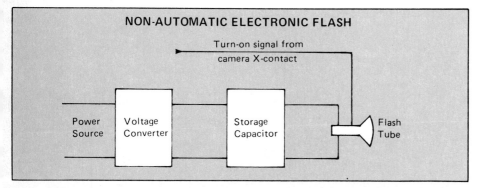

A non-automatic, or manual, flash is triggered by an electrical signal from the X-sync contact in the camera. The flash makes light until the storage capacitor in the flash has discharged its stored energy.

FLASH

I recommend the use of electronic flash because the advantages are overwhelming. Electronic flash units are light-weight, normally reliable, as costly or inexpensive as you choose, and are generally convenient. Besides the manual flashes you can use, many of the currently available electronic flash units feature built-in photocells for automatic exposure control. This frees you from guide-number calculations during spur-of-the-moment situations.

How a Flash Works—Batteries or other power supply charge a capacitor in the flash. The capacitor absorbs as much electrical charge as it can hold and stores the charge until an outside electrical signal causes the charge to be released to the flash tube. This makes the gas in the tube create a brilliant flash of light. The capacitor is drained of its electrical energy, and the batteries begin to replenish that charge.

The necessary time for the power supply to rebuild the charge in the capacitor is called the *recycle time*. The greater that time, the longer you must wait to make the next exposure. This is a very basic explanation, but our aim is to use the flash, not build it. What I've described is the operation of a non-automatic "manual" electronic flash. Before I discuss the automatic units in detail, you must be aware of some important flash characteristics.

Power Supply and Recycle Time—When you fire a manual flash, the entire charge in the capacitor is released. Obviously, there is a considerable drain on the batteries to replace that charge. As battery charge is reduced due to repeated flashes or old age, recycle time becomes longer. There is a greater time interval between the flash and the time when the next flash can be made.

A workable recycle time for wedding photography is between four and eight seconds. If you use a small flash unit powered by AA batteries, you will probably find that after an extended use of about an hour the recycle time increases to 20 seconds or longer. This is not good because many picture situations won't wait that long.

There are two remedies available to you. You can replace the worn batteries with fresh ones of the same type, or use batteries of the same size with more capacity. You're thinking of a third remedy, I imagine, and that would be to plug the flash directly into a wall outlet, if your flash has that option. Even though it is a solution, it is impractical for wedding photography.

The most useful procedure is to equip your unit with batteries, such as alkaline cells or rechargeable nicad cells that have a large capacity. Not all flash units can use rechargeable nicads, so check the instruction booklet of your flash. If you use a flash with rechargeable batteries, make sure to carry an extra set of fully-charged batteries with you. You will never have enough time to recharge batteries if your only set runs out of power.

Automatic Electronic Flash—The automatic electronic flash works in the same basic way except for one important feature. A photocell measures light reflected from the subject being photographed. The photocell is usually built into the flash but some are removable so they can be mounted in the camera hot shoe. In addition, some are built into the camera body. Light reaching the subject is reflected toward the photocell, which reads the light and cuts the flow of energy from the capacitor to the flash tube when exposure is correct.

With modern "energy-saving" flash units, the capacitor is seldom completely drained of its charge, so very little capacitor charge must be replaced by the battery. Recycle time for automatic units can be a fraction of a second, and useful battery life is longer as well. In addition, most automatic units can be switched to manual operation, allowing maximum light output at maximum flash duration.

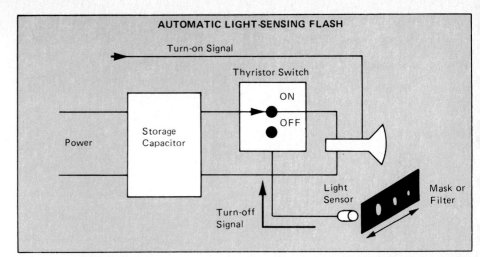

An automatic flash is turned on by the camera and turns itself off when its light sensor "thinks" exposure is correct.

If you connect the flash to your camera's X-sync circuit with a PC cord, be sure to test the cord prior to the start of a job. PC cords tend to fail at the worst possible times, so I suggest you always carry a couple extra to be safe and not sorry.

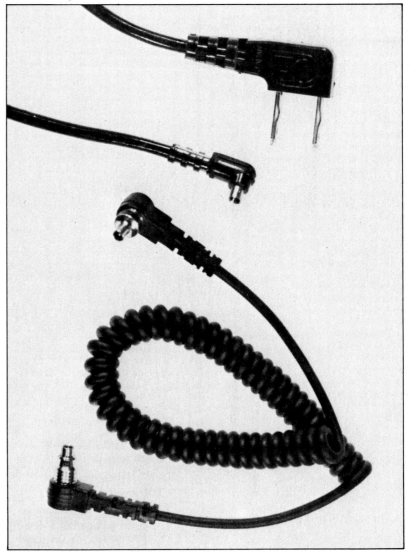

With the unit in automatic mode, the amount of light is controlled by flash duration. This time can be as brief as 1/50,000 second. The flash manufacturer supplies information giving the proper aperture setting and effective flash-to-subject distance for a variety of films. For example, suppose you are exposing film rated at ASA 100, and the manufacturer recommends an aperture setting of f-4 for subjects at a distance of three to ten feet. By setting the lens at f-4, you can focus on any subject between three and ten feet and be assured that the flash will provide proper exposure of the subject.

The automatic-exposure capability may be inadvertently defeated, however, if you are taking pictures in small areas with light colored, highly reflective walls. Too much reflected light is received by the photocell, and the light is cut off too soon, causing underexposure of the subject.

The reverse is true when photographing outdoors at night. The subject may be overexposed due to the lack of reflecting surfaces nearby.

The automatic feature is designed to work properly in *normal* surroundings. In situations such as those mentioned, I advise you to operate the flash unit in manual mode according to the manufacturer's directions or do tests to determine the aperture adjustment to use in non-normal environments. In addition, you could bracket.

I suggest you calculate flash exposure at night by using the flash guide number (GN). Divide the subject distance into the GN for the flash and film speed you are using to get the initial aperture setting for the lens. Then open the aperture another step to compensate for the lack of reflecting surfaces. For this photo, photographer Diane Ensign-Caughey used a shutter speed slower than 1/60 second to record the multicolored clouds at sunset.

THE TWO-LIGHT SETUP

If one light is good, two lights must be twice as good, correct? In this case, yes. One of the most common problems facing any photographer is the necessity to control the dark, unwanted shadows sometimes created by flash. In this respect, wedding photography is no different. A well-placed second light can make a nice picture an outstanding one. It's particularly effective when working with groups or when the subject must be placed very near a wall. The necessary equipment includes:

Two electronic flash units.
A method of triggering the flash that is away from the camera.
An extra set of hands.

To trigger the distant unit, a small photocell called a *slave* is necessary. When the flash at the camera is fired, the photocell attached to the second flash receives a part of that light and triggers the second flash. This takes place so rapidly that both lights appear to fire at precisely the same time. The extra set of hands is an assistant to hold the second flash unit in the appropriate locale.

Two Lights Step-by-Step—I'm going to describe a typical two-light situation, and if it sounds complicated, it is only because you haven't tried it and been rewarded by the results.

The bride and groom are standing in front of you at floor level. Your camera is equipped with the flash unit you have been using for previous photographs. The extra hands, with assistant attached, are holding the second flash unit equipped with the slave unit.

The second light is held at a 45° angle to the couple and at a height of approximately eight feet. The second light is actually used as the *main*, or *key* light, and is responsible for providing the proper amount of illumination for the exposure. The lens aperture is first

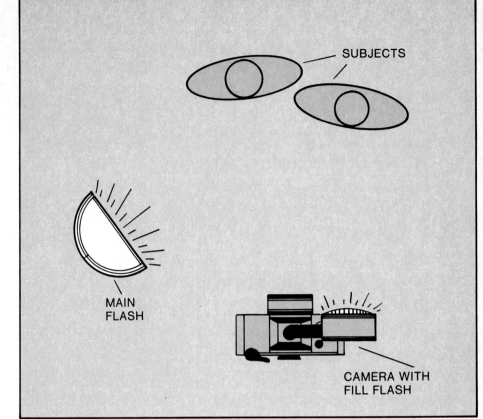

This shows the arrangement for the two-light setup described in the text. The main flash can be attached to a stand or held by an assistant. Either way, there must be some way for it to fire when the on-camera flash does. Do this with a long PC cord, or better yet, use a slave cell.

The distance from the subjects to the main flash determines the initial aperture setting. Adjust the camera-to-subject distance or fill flash output so the fill flash gives one step *less* light than the main flash. Then close the lens aperture about one-half step to compensate for areas lit by both flashes.

adjusted to the proper aperture for that light-to-subject distance.

The camera flash is used as the *fill* light, which reduces the harshness of the shadows caused by the main light. As a fill light, it should provide at least one step less light than the main light.

If your camera placement does not naturally give the one-step difference you can adjust the calculator dial of the automatic unit. Do this by entering a film speed one step faster into the dial. Then close the lens aperture a half

step to compensate for the areas lit by both flashes.

If the camera flash is operating manually, you could simply cover the flash face with a single thickness of clean, white handkerchief instead. It will cut the flash output by one half. A double thickness will decrease light output by half again.

My experience indicates that one thickness of material will provide the desired results, whether or not the calculated figures balance. Practice prior to the wed-

These charming newlyweds were photographed with a two-light setup. The shadows on the subjects are open and full of detail, lending a sense of depth and form. Flat lighting from one on-camera flash can't do this. You can also identify this photo as the result of a two-light setup by the two catch lights in the subjects' eyes. Photo by Steven A. Sint.

ding day so you will have the opportunity to make any small changes in order to insure the exact results you wish to achieve.

Once the second light is in position in a two-light setup, test fire the camera flash to be sure the slave is working and the second flash is firing. Make the assistant responsible for placing the second light in the proper location for each picture and checking to see that it fires each time.

Before you leave for the wedding, be sure you have thoroughly checked all flash cords and con-nections and are certain they are functioning properly. Then be sure you have an extra set. Sync and power cords can fail without warn-ing. Check all batteries and replace any that may not be in excellent condition. As with the cords, be sure to have extras.

A single, on-camera flash can create harsh shadows and bright spots, as in the photo at left, because the size of the source is small relative to the flash-to-subject distance. This kind of light is called *hard light*.

If you increase the size of the source relative to flash-to-subject distance, *softer light* results. The effect of soft light is shown in the photo at right. Notice how the subjects are lit evenly and shadow edges are softened.

You can soften the effect of a single flash by using the Larson *Soff Shoulder*, shown below. The reflector effectively increases the size of the light source and locates it a bit higher and more to one side than a typical on-camera flash. This way you can simulate the effect of a two-light set-up with only one flash. Photos courtesy of Larson Enterprises.

OTHER LIGHT SOURCES

There are, of course, other light sources available. These include photofloods, tungsten-halogen lamps, reflective material for reducing shadow density, and even natural sunlight. These will be discussed in a later chapter when I deal with portraits. I will not include them here because I believe the use of artificial lighting other than flash is a hazardous practice during the wedding and reception. In addition, the use of such lights at the wedding requires great experience on the part of the photographer and a very generous and patient wedding party.

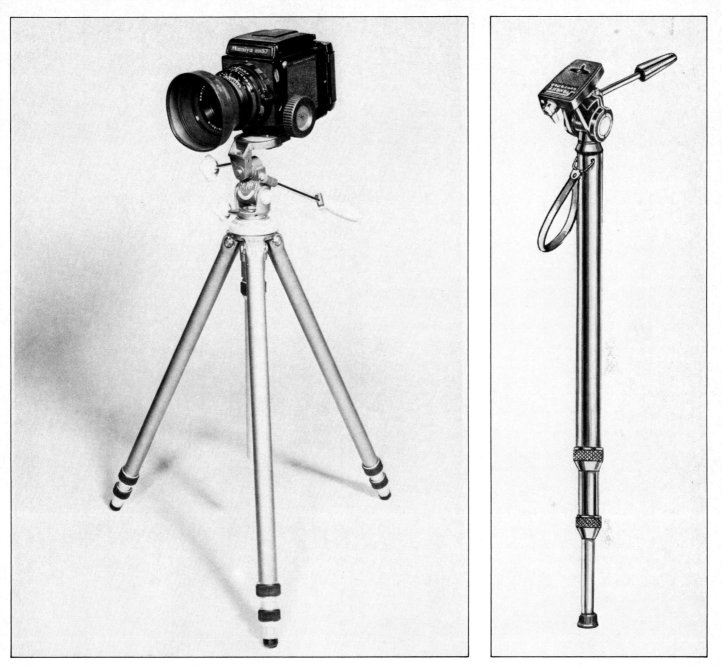

For most group photos, a good tripod is essential. I recommend you use one that is both sturdy and relatively light, as is the Gitzo tripod shown at left. The Stanrite Unipod shown at right can be useful for candid and informal photos when you want both a sturdy camera support and quick camera handling. Basically, your two legs and the unipod make a tripod-type support for the camera.

THE TRIPOD

A tripod is essential for group photography following the ceremony or at the reception. A group is difficult to manage and direct, especially when you are using the camera hand-held. Placing the camera on a tripod allows greater composition control, more accurate focusing, and far better direct communication between photographer and group, even when you use a flash. You have to carry the tripod some of the time, so weight considerations are important.

The tripod must be as compact as possible for travel, extend to at least your eye level, and be solid when fully extended.

Many tripods are designed to barely support 35mm cameras. If you use 35mm consistently, I suggest you find a tripod capable of supporting medium-format cameras. Adding heavy, long-focal-length lenses, flash units and battery packs very quickly overburdens the tripod rated for 35mm and smaller cameras.

There are many brands available at your photo dealer. With these requirements in mind, you may base your decision on your purchasing power and anticipated need for the jobs you'll do.

THE CARRYING CASE

Commonly referred to as the *gadget bag*, the carrying case is an important item because it is where your equipment and film are protected much of the time. As with tripods, there are several different kinds from which to choose. Once a few requirements are met, the selection is left to your individual needs.

The case must keep your equipment secure, protected, and separated. I recommend cases equipped with a divider that enables you to place items in individual compartments. This helps keep them free from damage, but still readily accessible. Also, look for a case that is spacious enough for any-thing you feel you need to have on the job. Once the case is packed with all the necessary paraphernalia, the weight will be considerable, so try to keep the weight of the case itself to a minimum.

I have tried many camera cases over the years and I finally found one that suits my purpose best. It is a fiberboard case designed for the old Graphic View camera. It measures approximately 13-1/2 inches high, 20 inches long, and 9 inches wide. It keeps my equipment organized and protected and is even sturdy enough to support my weight on the rare occasions when I need to gain a bit of extra height. A similar case was made for the Graflex Speed Graphic camera, which is also no longer in production. If you shop around, you might find such a case at a reasonable price.

Good fiber camera cases with divided compartments are sturdy, and the contents are available in an instant. Metal cases are even sturdier, but more expensive. Before you go shopping, arrange your equipment on a table, as you would in a case. Determine the space requirement, then see your photo dealer. Be as cost-conscious as you like, but remember that fine equipment merits fine protection. And in most cases, you get what you pay for.

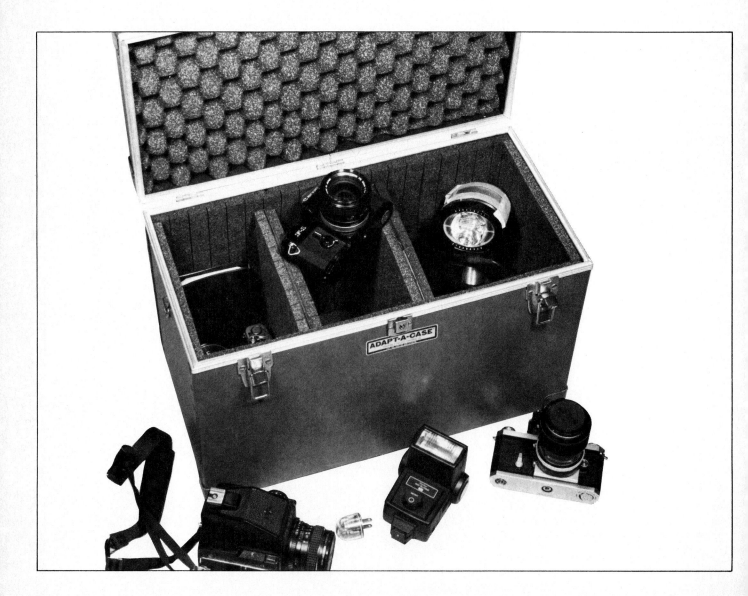

A WARNING ABOUT CAMERA CASES & SECURITY

Remember that many camera cases are prime targets for thieves because of what they hold. Sad to say, even our houses of worship are not free of thievery. Only a few years ago an equipment case could be left unattended anywhere in a church. That is not so today.

Ask a responsible person at the wedding site to locate a safe area where you can leave equipment. I recently did a wedding in a part of town where the incidence of theft was particularly high. The lady in charge of the church warned me of the situation and directed me to a small room near all activities where my equipment could be stored under lock and key.

For this wedding I had chosen to use 35mm SLR equipment for everything except the formal group photographs following the ceremony. I wished to use a larger format camera for those photos. Everything went extremely well until I needed the larger camera. The equipment was safe, in fact, even safe from me. I couldn't find the lady with the key. To compound the matter, no one else could find her either.

The wedding party was at the altar, and the guests were at the front door, their anxious hands full of rice. There was nothing to do but make the photographs with the 35mm camera, one flash and no tripod. It worked, but certainly not as I had planned. Although the bridal couple was pleased with the finished work, I was disappointed with what I felt was something less than top-quality group photographs. I've often wondered what the results might have been had I arrived a bit earlier and locked *everything* into that small, safe room. Remember to find a safe location that is easily accessible.

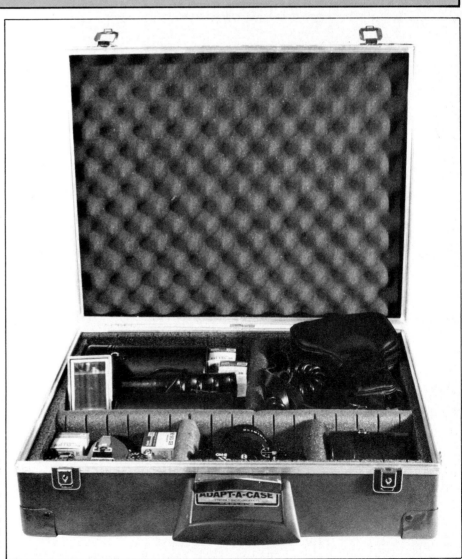

The Adapt-A-Case shown at left is similar to the old Graphic View case described in the text. It is a very large fiber case that will easily hold everything you need for a day's work. If you need less stuff, consider using the smaller model shown on this page. Both models come with removable, foam-covered dividers that let you tailor the case's compartments to fit your equipment.

2
Film, Filters and Available Light

Film selection is important. I suggest you make your choice carefully, based on your experience with different films and the demands of the assignment.

B&W VS. COLOR

Although most weddings are photographed in color, there is still some demand for b&w wedding photographs. Weddings are still recorded on b&w film because the materials are usually less expensive. However, most people prefer color photographs because they see them as more natural; therefore, more appealing. All around us are books, magazines, television sets, billboards and countless printed items ablaze with color. It's part of our daily existence and has come to be expected. Still, there is always the chance you will be asked to photograph a wedding in b&w, so let's start with that.

B&W PHOTOGRAPHY

Ask an established professional photographer and he or she will probably tell you that a good b&w photograph is more difficult to produce than a good color photograph. The reason is that color is easier artistically. The artistic value is what sells the wedding photo and makes it worthwhile.

Think for a moment about a rose. A rose is beautiful not merely by virtue of its color, but by its shape as well. If the color reproduced by the photograph is reasonably accurate, many people are willing to overlook errors in such things as focus, lighting and composition. Such is the power of color. In a b&w print, the color is lacking so we are forced to judge the work solely by those things we were willing to disregard in the color image. This means that if you are going to work in b&w you need to know what to do and how to do it.

When considering a b&w film for wedding photography, remember that you will usually deliver 8x10 enlargements. If you use a fast, grainy film, the customer may not like the apparent grain of the print. If you use a slow, fine-grain film and hand hold the camera without using a flash, the images might be blurred due to long shutter speeds.

You have to consider all of the possibilities of light, enlarging, and the image quality the customer expects. Of course, this usually leads to a compromise that lets you use existing light or flash and yields high-quality prints when enlarged. I think medium-speed films are an ideal choice in this case. See the table on page 27 for a list of b&w films you can use.

When you finally choose the b&w film you want to use, test it and learn its characteristics. Just like your camera and flash, you must be comfortable with and knowledgeable about your film ahead of time.

PROFESSIONAL OR AMATEUR COLOR FILM?

A factor in choosing Kodak color film is whether to use film intended for the professional or amateur photographer. When the word *Professional* is part of the name in Kodak color films, it means that the film is made to have optimal color balance when it is shipped, and it will not change as long as it is refrigerated prior to use. However, you can store the film for a short time unrefrigerated, such as two weeks at room temperature or two days at 120°F (49°C), and not see any difference in the processed film.

Film-speed tests are done on each emulsion batch of professional film before it leaves the factory. The recommended speed is then printed on the data sheet enclosed with the film. This speed can vary one-third step in either direction from its nominal ASA speed. The speed on the data sheet is accurate to within one-sixth step.

Films intended for the amateur photographer are made to reach their optimal color balance *after* they are shipped, so they eventually meet the standards of film users, as determined through customer-preference tests. Variance from the nominal film speed is not printed on the data sheet, so you should test the film yourself if you want an accurate speed rating. If you buy a bulk supply of amateur film of one emulsion batch, you can preserve a certain color balance and speed by refrigerating the film when it meets your standards.

The differences between the films do not mean that professional film is better than amateur. Rather, they let you choose a film that is compatible with the way you buy and use it. Photographers who make bulk purchases of professional film in cartridges or 100-foot rolls test part of an emulsion batch and do not want the characteristics to change from roll to roll. Many people buy small amounts of film at one time, and sometimes the film stays in the camera for weeks or even months. Amateur films accommodate this kind of user.

For best results, whether you buy professional or amateur film, keep unexposed and exposed film cool and do not subject it to high humidity. Have any exposed color film processed as soon as practical after exposure, or refrigerate it until it can be processed.

If this scene was of your wedding ceremony, which print would you prefer? I think most people would prefer the color photo because we are so used to color imagery. This is why I recommend you use color film for most wedding photos.

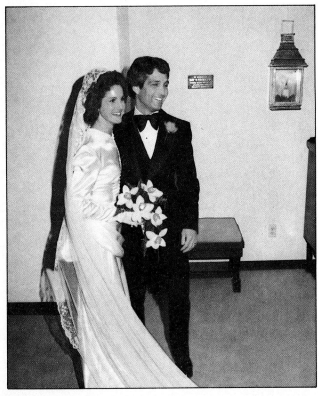
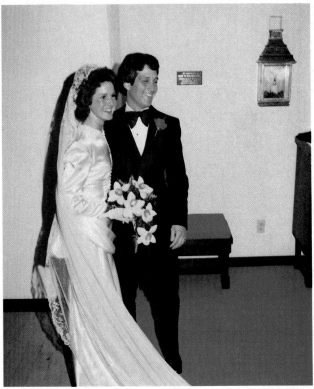

COLOR PHOTOGRAPHY

As shown in the accompanying table, there are many color films. When choosing the one to use for wedding photography, you have to consider the same things you do with a b&w film, with the additional factor of color balance.

Again I recommend a medium-speed film because you can use it for most of the situations that will occur. Because you will use flash much of the time, a daylight-balanced, medium-speed film should be your choice.

Negative vs. Transparency—The major reason most wedding photographers prefer color negative film is that it has a much longer exposure range than slide film. You can overexpose two or three steps and still get a printable image.

Of course, I'm not recommending overexposure or sloppy exposure calculations—good exposure will always yield the best image quality. However, slide films get lighter with overexposure, and there is no way to correct this in the printing process. I think you should use slide film for a wedding *only* if you have complete confidence in your equipment and are quite experienced with the film you are using.

This photo was made from a color negative that was underexposed about two steps. I didn't present the proof to the couple because *I* was dissatisfied with the image quality. However, some people may find it acceptable.

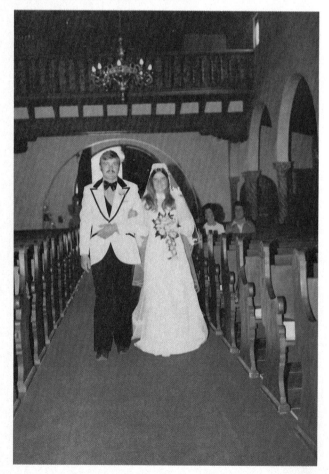

This image is from a color slide that was overexposed about two steps. No sensible person would consider it acceptable.

COLOR CONVERSION FILTERS

Each type of color film is designed to be used with a particular light source. However, if the film is not balanced for the light source, you can still make properly exposed and color balanced negatives and slides. To do it you use a color conversion filter. The filter is placed over the camera lens and effectively alters the color of the light striking the film to that for which the film is balanced. Let's look first at the color shift experienced without filters.

Film	Light Source	Color Shift
Daylight	Sun or electronic flash	None
Daylight	Fluorescent	Green
Daylight	Tungsten	Orange
Tungsten (Type B)	Sun or electronic flash	Blue
Tungsten (Type B)	Fluorescent	Cyan
Tungsten (Type B)	3200K Tungsten	None

The use of color conversion filters corrects for color imbalance; however, the filters also add a certain density which must be compensated for to obtain proper exposure.

Film	Light Source	Filter	Step Increase
Daylight	Sun or electronic flash	None	None
Daylight	Fluorescent	Tiffen FLD*	1
Daylight	3200K Tungsten	80A	2
Tungsten (Type B)	Sun or electronic flash	85B	2/3
Tungsten (Type B)	Fluorescent	Tiffen FLB*	1
Tungsten (Type B)	3200K Tungsten	None	None

* or equivalent filter

This photo was made from a color negative that was overexposed about two steps. Image quality is not great, but everyone in the photo was pleased by his or her likeness.

SOME 35mm ROLL FILMS	
FILM	**ASA**
Black & White	
Agfapan 25	25
Kodak Panatomic-X	32
Ilford Pan F	50
Agfapan 100	100
Kodak Plus-X	125
Ilford FP 4	125
Agfapan 400	400
Kodak Tri-X	400
Ilford HP 5	400
Color Negative	
Fujicolor F-II	100
Kodacolor II	100
Vericolor II	100
Fujicolor F-II 400	400
Kodacolor 400	400
Color Slide	
Kodachrome 25	25
Ektachrome 50	50
Agfachrome 64	64
Kodachrome 64	64
Ektachrome 64	64
Ektachrome 160	160
Ektachrome 200	200
Fujichrome 400	400
Ektachrome 400	400

AVAILABLE LIGHT

The purpose of available-light photography is to create a photo that appears either dramatic or very personal. There is a certain amount of intimacy involved in available-light photography because when it is well-done we feel like we are sharing a private moment or relationship, unobserved and without intruding. That's not to say, of course, that we should feel guilty about such pictures, but rather that such feelings mean the photographer has done his or her job well.

There are different ways to handle available-light scenes. I'll describe four scenes that occur quite often. Remember that available light does not always imply low-light. You do not always need the fastest available film pushed two steps. Choose the film that can do the job best, based on your experience.

In each situation, the subject is one person, a young lady, in a typical available-light environment. We will use a 35mm SLR camera with a standard lens. The camera is mounted on a tripod. Please notice that the mention of the tripod is not a recommendation, but a statement of fact.

Situation 1—The lady is seated in a room lit only by standard household lamps. There is a lamp on either side of her, and each fixture contains a single 100-watt bulb. She is seated slightly closer to one lamp, which acts as a main light source. The other lamp provides light to fill the shadowed side of the subject's face.

To make a b&w exposure, a fast film such as Tri-X will work well. Make an exposure reading in the

When the only available light is a mixture of artificial sources, you may be surprised at the resulting color reproduction. When in doubt, try to light the main subject with the source that most nearly matches the color sensitivity of the film you are using. Photo by Steven A. Sint.

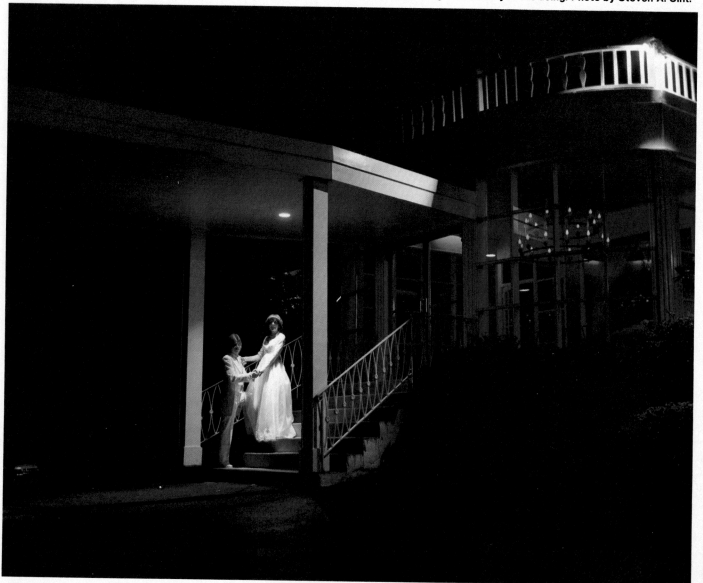

usual manner. There is nothing tricky here, so concentrate on focus, composition and capturing a pleasant expression.

You could use a color negative film in the same way. When the negative is printed, the color will be a bit warm because of the color quality of household tungsten lamps. The warmth will heighten the mood of the picture, rather than interfere. If you use a slide film, choose one that is balanced for tungsten light because it is more closely balanced for the light than a daylight balanced film. It will still yield a slightly warm tone.

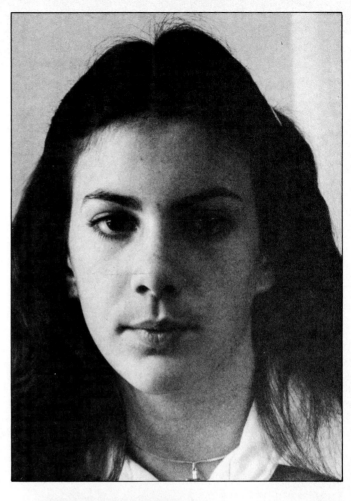

The fill lamp adds light to the shadows created by the position of the subject relative to the main lamp.

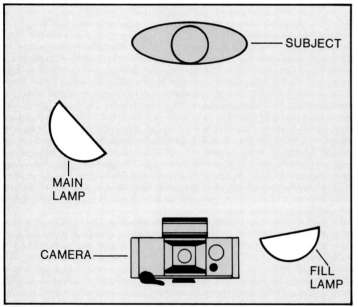

SUBJECT

MAIN LAMP

CAMERA

FILL LAMP

ANOTHER USEFUL FILTER

In addition to the color conversion filters listed, there is one other filter I recommend. The filter may be called a *skylight, haze* or *UV* (ultraviolet) filter. It is designed to reduce excess blue caused by ultraviolet radiation. In color photography the blue is noticeable in shadows, and in b&w photography excess blue creates haze. The filter requires no increase in exposure and can remain on the camera lens at all times for all films, whether b&w or color. Frankly, I think that the greatest advantage of the filter is the protection it gives the lens from fingerprints and injury. It's better to scratch a $10 filter than a $150 lens.

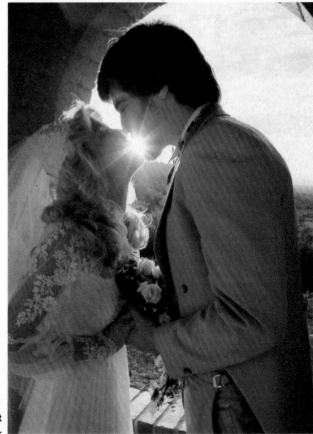

The warm, golden light of early sunset combined with an intimate moment makes this available-light scene work well. Photo by Diane Ensign-Caughey.

Situation 2—This arrangement is similar to the first, except that the young lady is lit by only one lamp. The difficulty is that without the second light acting as shadow fill, one side of her face is completely dark. This creates a very dramatic scene and photographs may be made for that purpose. If drama is the intent, make the exposure based on the meter indication of the lit side of the face. The shadow side will be very dark, but the lack of detail contrasted against the lit side fulfills the purpose.

If you don't like the effects of deep shadows, you must change something, either in the pose or the lighting, so the contrast is reduced. Background allowing, the subject may be turned so that her face is fully lit by the single lamp. Of course, it may mean changing camera position, but this is the simplest corrective measure.

The alternative is to increase the amount of light on the shadow side. You can do this either by placing another lamp nearby, which puts you back to Situation

1, or by using a reflector so light from the existing lamp is reflected back into the shadow. Make a simple reflector by covering a 16x20 inch piece of cardboard with aluminum foil.

Due to the relatively low light level, the reflector must be held fairly close to the face. Be very careful that it does not get included in the frame. The shadow area filled by the reflector will still be darker than the same area lit by the fill lamp in Situation 1, but the mood will be quite pleasing.

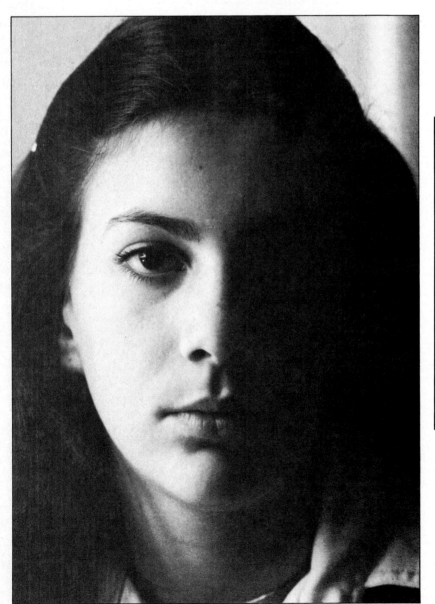

Without any fill light illuminating shadows, they will lack detail. This is OK if it is the effect you want to record.

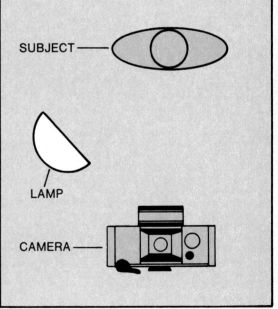

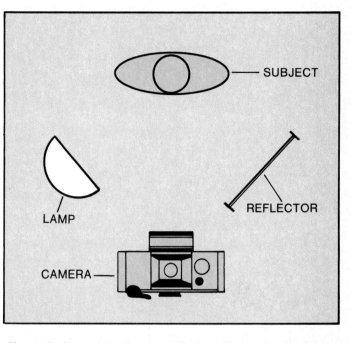

A simple change in subject position will reduce the amount of shadow area when the subject is lit by only one light.

If you don't want to change subject position, yet still wish to reduce shadow area, use a simple reflector to bounce light into the shadows.

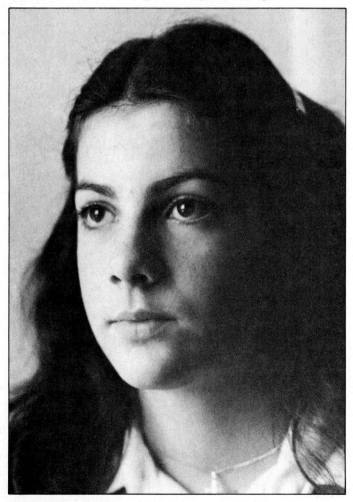

Situation 3—A very common picture possibility found at home or at church during daylight hours occurs when the young lady takes a position near a window or open door. This situation is very much like Situation 2, but with light of daylight quality, 5500K, and a great deal more of it.

Because the light is primarily daylight, use a daylight color film if you are not working with b&w film. Even though the amount of light is now greater than with the lamp arrangements, use a medium-speed or faster film. At first glance, this scene seems simple and straightforward. It is not because of several factors that must be considered.

Direct sunlight through the window or door should be avoided unless the lady faces it head on. Direct sunlight falling on only one

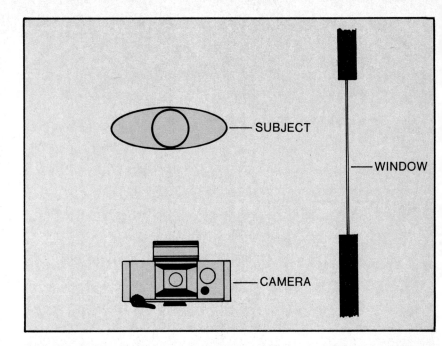

Window light on one side of the face creates a contrasty effect similar to the photo of Situation 2 on page 30. However, window light will probably be more intense and of a different color temperature than light from a tungsten bulb.

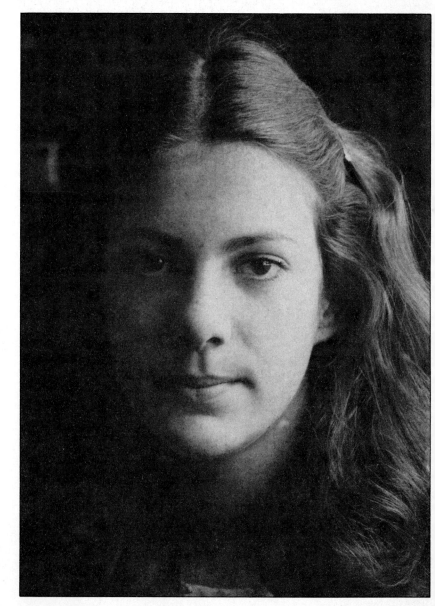

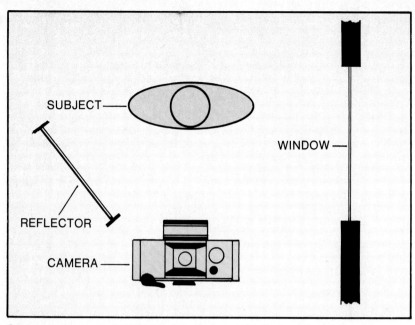

Control the amount of fill light in the shadows with the location of the reflector. The closer it is to the subject, the more light it will reflect onto the subject.

side of the face creates an extreme contrast range and is usually undesirable unless you want a dramatic portrait.

Light from a clear sky through a window facing north is preferable in most cases because it is soft, diffused, and generally more flattering to feminine features. Even though this light is softer, some source of fill light toward the shadow side of the face may be desirable. Once more, the aluminum foil comes into play as a reflector returning a bit of the window light back onto the shadow side of the face.

When working near a window providing light from a clear sky, be aware that you are working with very blue light. Avoid the blue shift in color films by filtering the lens with a Skylight or UV filter.

Bright silver Reflectasol reflectors made by Larson Enterprises are extremely useful for lighting situations such as this. The reflectors are light, portable, collapsible, and available in a variety of sizes. The reflectors shown can be used flat or in a dished shape.

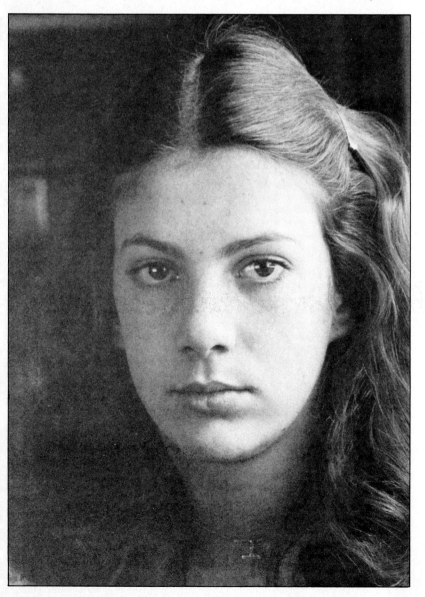

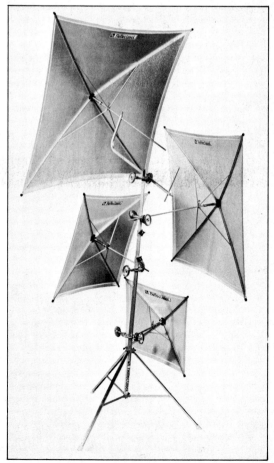

Situation 4—When the subject is lit by tungsten and daylight in nearly equal proportions, your dilemma is the choice of film. Should you choose tungsten film for the tungsten light or daylight film for daylight? You must react to each arrangement using your own best judgement, but there are some guidelines that may help. Determine which light source is preferable because of its intensity, direction, or evenness. Arrange the subject so the full face is illuminated by that source only. Use film balanced for that source.

In mixed-light situations, balanced color may be achieved by first determining the preferred source, then filling shadow areas with light of the same quality. For example, you may prefer to photograph with daylight through a window, with the opposite side of the face lit by tungsten bulbs in household fixtures. An electronic flash toward the tungsten side of the face will overpower the unwanted red and restore the proper daylight balance. If you're using tungsten film, a foil reflector, if large enough, will reflect tungsten light into the shadow while blocking the daylight from the window.

This situation is obviously not an easy one, and you must give it serious thought. If the solution is quickly apparent, use it. If it is not, you must decide quickly on a course of action. Either let the situation pass and look for a better place and moment, or make the exposure. Keep in mind that the end result may be discarded, unoffered to the customer.

I've certainly not covered all available-light situations, and as you go through the wedding process you will see the reason why. There are so many variables, such as time of day, room size, type and amount of existing light, and available working time, that each event will prove to be unique.

In this photo, both daylight and tungsten sources illuminate the scene. Light coming through the windows behind the couple create a blue cast in the background because the windows face north. Tungsten room lights mixed with reflected window light illuminate the front of the couple. Because the tungsten light is more intense than the reflected window light, the couple is predominately lit with soft, golden light, which lends a flattering effect to a nice scene. Photo by Diane Ensign-Caughey.

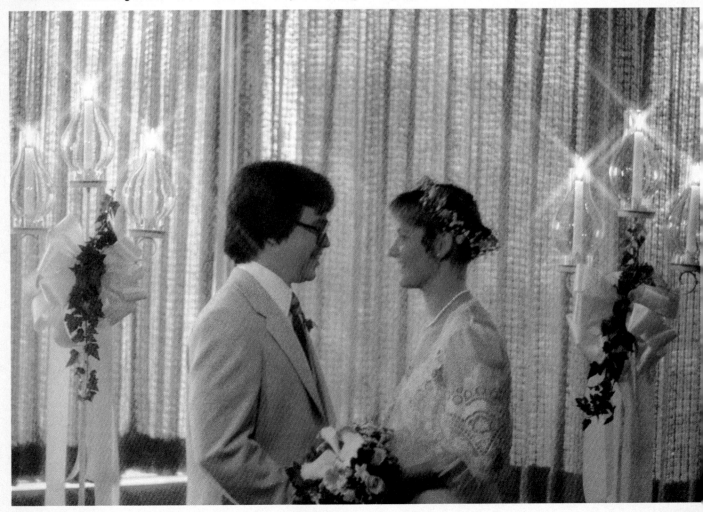

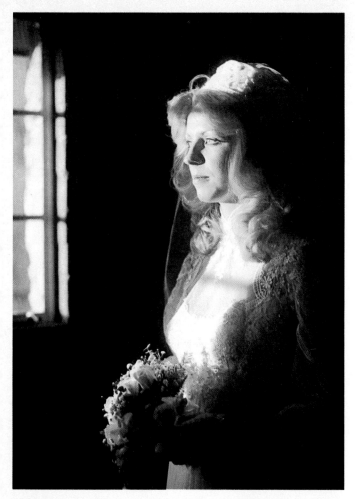

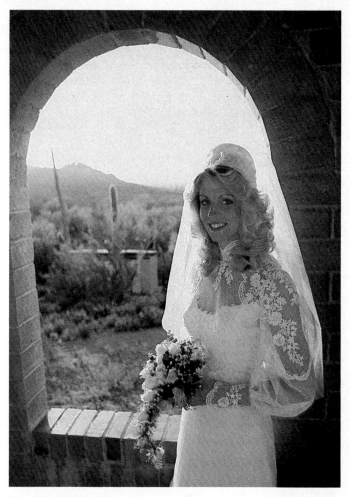

Light from a setting sun can be weak, necessitating slow shutter speeds. Even so, the effect can warrant the extra effort making the photo may involve. Photo by Diane Ensign-Caughey.

Not all available-light photos require slow shutter speeds. This photo was made while the sun was still relatively high in the sky, so it could be used as a source of warm back light. Reflected sunlight illuminates the front of the bride. Photo by Diane Ensign-Caughey.

Advantages and Disadvantages— Available-light photography is advantageous because a feeling of intimacy is created and the subject appears more natural. The viewer has a greater awareness of the atmosphere of the event. A well-done available-light photograph indicates that the photographer is not an intruder because it shows your subjects in a truly candid manner.

The disadvantages are that a low light level can require longer exposures with the possibility of camera or subject movement causing blurred pictures. As I've mentioned, color balance can be a great problem as well. Even with these drawbacks in mind, don't forsake using available light out of fear of failure. Often, a picture will create such a pleasant feeling that a slight deviation in focus or color balance can be overlooked and be of far less importance than the overall scene itself. Don't ever be afraid to try because *you* are the judge of which photographs the customer sees for final selection. If you try and fail, don't show the photograph. If you try and succeed, you'll be pleased by the response.

If you want to use available light for wedding coverage, use two cameras when possible. Load one with medium-speed film for use with daylight outside or electronic flash indoors. Load the second camera with high-speed film for available-light photographs when the opportunity arises.

Actually, most photographers use one camera and one type of film for the entire event. If that is you, don't limit yourself to either flash or existing light. When using medium-speed film, many occasions for available-light photographs will present themselves. In these instances, you must remember to remove the sync cord from the camera and use a meter to determine exposure. What you may not remember, however, is to reconnect the cord prior to making the next flash exposure. Believe me, it's easy to forget and very embarrassing when everyone is ready for the flash except you.

Always Be Prepared—Later in the book I'll discuss the importance of visiting the wedding location prior to the day of the event. But let me mention now that for the best available-light photos you must be prepared beforehand.

Mentally establish the plan you will follow. Make your visit as near to the hour of the ceremony as possible so lighting conditions will be similar. Locate the places affording you the best opportunities. Take light-meter readings so you can make an intelligent film choice. Be prepared to work with the situation as it exists.

Available-light photographs are like photographs made with an extremely wide-angle lens. A few of them throughout the entire job are exciting, interesting and command considerable attention. Too many of them may be boring. By their very nature, available-light photographs can portray a pensive, almost withdrawn, mood. Certainly, these feelings are appropriate to the event. However, the total feeling of a wedding is bright, vibrant and joyous. This is best expressed though sharp, well-lit photographs. These are most often made with sunlight or electronic flash. Use available light, but use it sparingly.

Always consider stained-glass windows as a major element in an available-light photo. To make this silhouette of the wedding couple, photographer Diane Ensign-Caughey based exposure on the windows, *not* the light illuminating the front of the couple.

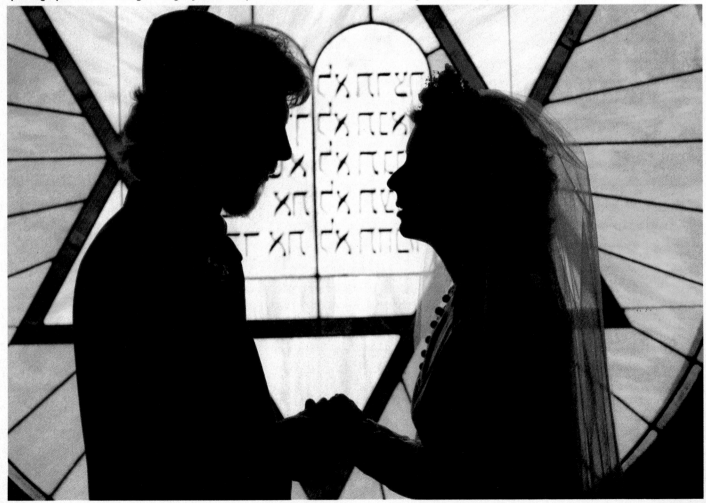

3
Lab Facts

If you get a proof that looks as scratched and dirty as this, *don't* have it enlarged. First check the negative to see if it contains the imperfections. If it does, you should discuss the problem with the manager of the lab. Negatives and prints improperly handled by the lab do *your* reputation no good.

Choosing a custom lab can be very difficult. If you live in a small town, you're most likely at a disadvantage because you probably don't have a full-service custom lab available. Full-service custom labs are most often located in cities providing a large business volume.

If you are situated near a good lab, you have the advantage of being in a position to deal with the people directly. It saves a great deal of time if you are able to request remakes on prints you feel are unsatisfactory at the time you receive the initial order. If you are using a mail-order lab, it is difficult to explain by letter the corrections you want made.

WHAT TO LOOK FOR

When selecting a lab, consider three things—quality, service and cost. Some labs are not noted for their cleanliness and tend to deliver prints with dust spots and fingerprints. Such prints won't sell well.

Some labs, usually those with the dust spots, accept your film only prior to closing for vacation. Or perhaps their business is so slow they want to make sure they have a full run before mixing chemicals. Either way, the wedding couple may be celebrating their first anniversary before you can deliver the album. That will

certainly cut down the order for additional prints.

I had the misfortune of dealing with such a lab once, but only once. I was unable to deliver the album for nearly eight months due to the carefree attitude of the printer and the continual remakes that were necessary.

Unfortunately, the couple split up after three months and after six months they were divorced. It was a great surprise for all when I showed up to present the order. No one wanted it.

Although I did use the photos as a sample book, it cost several times more than it would have if I had wanted to make samples.

Don't let this happen to you. Be assured beforehand of a delivery schedule that is satisfactory both to you and the wedding couple.

PROOFING

When ordering standard color negative processing and printing, order machine-made 3-1/2x5 inch prints. These prints are excellent proofs to show the customer. If some are of less quality than you expected, remember that machines can make mistakes too.

Check the negatives to see if the problem lies with your exposure in those particular frames. If the negative appears normal, request the lab to reprint and tell them why—the print is too dark, too light, off color, etc.

Don't make a big deal over a picture that is out of focus or one you wouldn't have presented to the couple anyway. A print slightly out of focus at 3-1/2x5 will be considerably worse at 8x10.

You will always have some prints that are a total waste. Those are the ones that seemed like a great idea at the time of exposure, but only then. Don't be afraid to throw out any proofs that you feel are unworthy of presentation due to failure of technique or lack of interest. Show only those proofs that are well done and, in your opinion, salable.

Don't show proofs that are out of focus, unprintable, or meaningless. Not only are they embarrassing, but they won't sell.

At first glance, there is nothing wrong with this photo. Exposure, composition, and color balance are admirable. However, one of the ushers has his eyes closed, which in my opinion makes the photo unusable. Carefully check proofs to see that all eyes in a group photo are open. Then be sure to properly identify the negative used to make that proof.

Mark the Proofs—When the print proofs are returned from the lab, be sure to mark on the back of each print the number of the roll and frame from which the print was made. If the proofs are not numbered before you deliver them to the bride and groom, matching the print to the frame is a nuisance once the order is placed.

This is especially true when you have several nearly identical exposures of a group picture. It always amazes me how a large number of people can remain perfectly motionless for the time it takes to make two or three exposures. The only difference in the negatives may be that someone blinked his or her eyes in one frame. Closed eyes can be hard to locate in group pictures. If you select the wrong negative for enlarging, you must absorb the cost of one unwanted enlargement.

Roll films have frame numbers along one edge of the film. Use these numbers and roll numbers to identify each proof. For example, if these images were from the second roll, prints made from the negatives could be labeled 2-15, 2-16, and 2-17.

COST

Regarding cost, the best advice I can give is to be aware of what you must pay for finishing expenses *before* you are committed to do the wedding and have quoted the price of the job. Your initial costs are for the film, processing, and proof prints made from each negative.

Your major costs are the 5x7 or 8x10 prints that become the wedding album. Standard 8x10 color prints can cost from $1.50 to $15 each, depending on the lab, the number ordered, the film size, and whether the prints are printed by machine or by hand.

In a brief survey of several labs, I find that a reasonably accurate average is $3.00 for the first 8x10 print and $1.25 for each additional print from the same negative printed at the same time.

These averages are for machine-made prints, which also means no cropping or dust spotting. If you need additional prints from a previously printed negative, you will be charged at the first-print price again. The lower price is only for additional prints made at the same time—that's an important thing to remember.

CROPPING

The most common problem in dealing with any lab is obtaining the cropping you want. Many labs are totally automatic, meaning that the printing machines are designed to print almost the entire negative area in the standard print formats: 3-1/2x5, 5x7 or 8x10.

If you have exposed a frame that requires drastic cropping, it must be done by hand rather than machine. If you have many frames of that nature, print costs increase dramatically. Therefore, pay close attention to composition when making the original exposure. Try to avoid cropping.

When cropping is necessary, make sure the instructions are unambiguous. Cropping instructions are easy to make on either the proof print, negative sleeves, or slide mount.

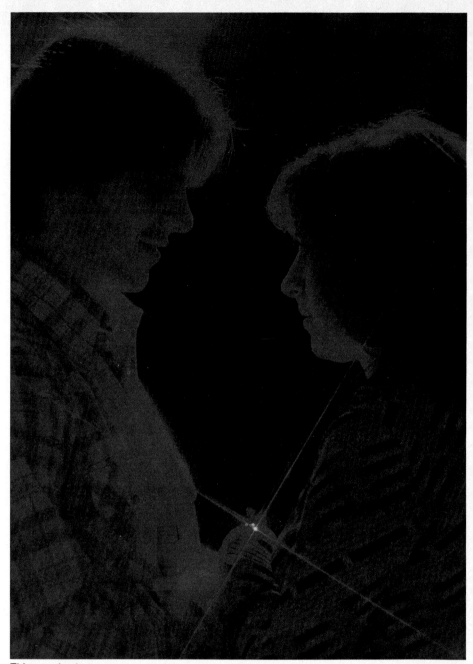

This moody photo was exposed through a red filter and a cross-star lens attachment. Without any special instructions to the printer, the photo would have had a different color balance and exposure due to "subject failure." When you shoot color negatives with color filters for a certain effect, be sure to indicate on the proof how the enlargement should look. Photo by Diane Ensign-Caughey.

When marking proofs, all you have to do is mark the approximate area you want eliminated by drawing some lines directly on the print, using a felt-tip marker. Be sure you use a marker that does not easily rub off.

Before marking the negative sleeve, use a piece of tape to secure the negative inside the clear plastic sleeve. Use a grease pencil to indicate the area to be cropped on the outside surface of the sleeve. Remember that the negative must be secure inside the sleeve so it won't slip and make the cropping marks useless. If the negative shifts position in the sleeve, the printer won't have any idea where to begin.

If you crop slide images, make the marks on the slide mount.

MACHINE-MADE PRINTS

When color negatives are printed by machines, they are first scanned by an analyzer that assumes all of the colors in the photographed scene integrate to an 18% gray tone. It automatically sets the printing machine for a certain exposure and filtration, giving well-exposed and properly color balanced prints most of the time.

However, the colors of some scenes do not integrate into an 18% gray tone. Typical examples of these are scenes of predominately one color, such as a close-up of a white wedding dress, or a photo shot through a color filter. In this case, the analyzer assumes the scene is *average* and tells the printing machine to make it that way.

The resulting print will not have correct color balance and possibly bad exposure too. This effect is called *subject failure*, even though the subject had nothing to do with the problem. It is a characteristic of automatic printing processes.

Some labs have people inspect all prints to catch those that indicate gross subject failure. They will then remake the bad prints based on more careful, human analysis of the negative, and you will never see the bad prints.

Even so, some machine-made proofs may not indicate the good job you did exposing the negatives. If you or the customer want them enlarged, be sure to indicate to the printer who will do the enlarging how you want the color balance or exposure to be improved in the enlargement. You can even write the directions on the back of the proof if you want. This is another reason to deal with a good custom lab. Remember, though, they will produce what you want only when *you* know what you want.

When making crop marks on proofs, use a grease pencil or indelible marker so the marks don't accidentally come off. When marking a slide, mark only the slide mount.

This multiple-exposure photo was done in camera by Steven A. Sint for Glenmar Photographers. First he made the exposure in the upper-right-hand corner while masking the rest of the frame. The exposure of the church service was made on the same frame while he masked the upper right-hand corner. The same image could have been done by a lab using multiple-printing techniques.

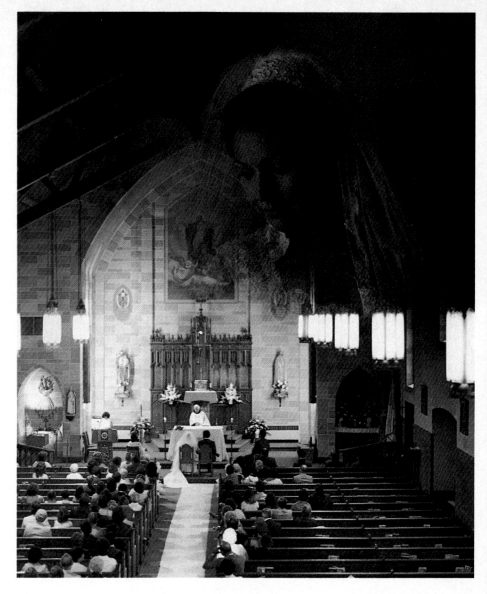

SPECIAL-EFFECT IMAGES

In wedding photography, the most common special-effect images are double exposures or prints made from more than one negative. I'm sure you've seen a photograph of a champagne glass filled with the heads of the wedding couple and wondered how the drink was mixed.

There are also combinations of floating heads in the church or multiple views of the bride. Personally, I don't like these kinds of photos because too often the images don't blend well or they seem totally incompatible.

Most of the time, neither image could stand alone, and I get the impression they were put together in the hope that one would support the other. Usually they don't.

Regardless of what I may think, the multiple image may be just the effect you desire. If so, fine, but now you have to see it through.

You can do it one of two ways. If you want to do it in camera, use a matte box and the multiple-exposure mechanism of your camera.

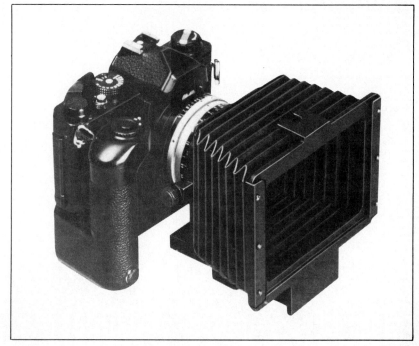

If you don't have a matte box and you still want to try a multiple-exposure image, improvise! Use any opaque card and fashion your own masks for the photo. For this photo, Steven A. Sint used the dark slide of his Hasselblad and an appointment book as masks he hand-held in front of the camera lens. Of course, the camera was on a tripod for both exposures.

The other way involves multiple-printing of the negatives on one sheet of paper.

You will most likely find that the local lab you have been using does not offer the multiple-image print. To find a mail-order lab that does multiple printing, look through some recent photography magazines and you'll find several labs advertising such services.

Be prepared to give detailed instructions as to exact placement of the images. Draw a sketch if necessary and be specific. Consider the time factor as well. Make sure the lab promises reasonably fast service so you can deliver the special print with the album.

If the specialty lab offers regular printing as well, you may want to send them the entire order. However, be sure that you will be satisfied with the quality and cost, as compared to your regular, local lab.

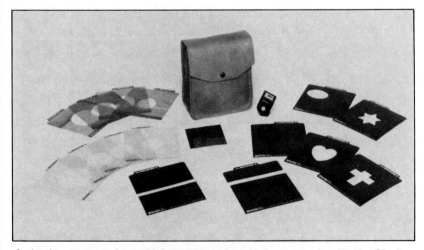

A simple way to make multiple-exposure images in camera is with the Shade + matte box shown on the opposite page. In addition to using it as a lens shade, you can also fit special-effect mattes into its front opening. These mattes, shown here, block exposure from certain areas of the negative, while allowing other portions to be exposed. Then you can use another matte to expose the unexposed areas of the same frame. Diffusion screens are also available for the Shade + for even more special-effects applications.

DOING YOUR OWN LAB WORK

Perhaps you have the facilities to do your own processing and enlarging. No matter how fine the commercial lab, nothing satisfies some photographers more than doing their own printing. No one can do the cropping or print manipulation in the manner you want nearly as well as you can.

Printing the negative yourself allows unlimited creativity and experimentation. Vignettes in various shapes, texture screens, multiple exposures or color shifts for effect are but a few of the many variations from the straight print that are available in your own darkroom. Just having the ability to crop unwanted picture areas is advantage enough.

If you are printing the job yourself, I recommend Kodak Ektalure silk surface for b&w negatives. For color negative printing, Ektacolor 74RC, which is available in glossy, smooth lustre, and silk surfaces, gives fine results. When printing your own negatives, consider making proofs in the form of contact sheets. The cost per sheet is low enough so you can make duplicates for the bride to send to relatives for their orders.

Even prints from slides are easy to make. Use Kodak Ektachrome Type 2203 RC print materials. There are other materials available, and if you prefer another, use it. However, I've tried them all and still believe Kodak's papers to be the most reliable and consistent. In addition, they are also readily available.

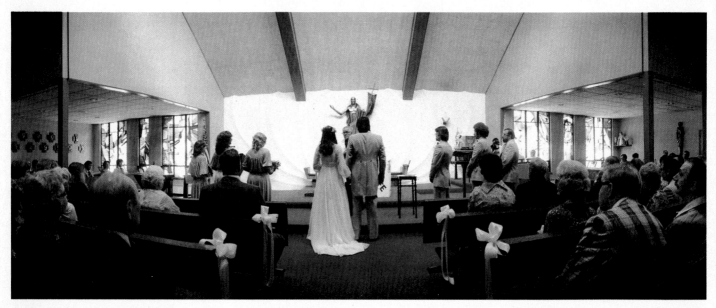

To make this picture, photographer Kathy McLaughlin used a special panorama camera called the *Widelux*. Because the image is longer than the standard 35mm frame, she printed it herself. Being able to do your own color and b&w printing may give you the creative edge that puts your work in demand.

COLOR FILM & PRINT PROCESSES FOR HOME DARKROOMS		
	Negative-to-Positive	**Reversal**
Film Processes	Beseler CN2 Color Negative Chemistry Kodak Flexicolor Processing Kit, Process C-41 Kodak Color Processing Kit, Process C-22 Paterson Acucolor 2 Negative Processing Kit Photocolor II Colour Processing Chemicals Unicolor K2 Color Negative Chemistry Unicolor Total Color	Beseler E-6 Processing Kit Kodak Ektachrome Film Processing Kit, E-6 Kodak Ektachrome Film Processing Kit, E-4 Unicolor E-6 Chemistry
Print Processes	Beseler 2-Step Color Print Chemistry Kodak Ektaprint 2 Processing Kit and Chemicals Paterson Acucolor 3 Paper Processing Kit Photocolor II Colour Processing Chemicals Unicolor R-2 Chemistry Unicolor Ar Chemistry Unicolor Total Color 1 and 2	Beseler RP5 Reversal Print Chemistry Ilford Cibachrome Process P12 Kodak Ektaprint R-500 Chemicals Kodak Ektaprint R-1000 Chemicals Unicolor PFS Chemistry Unicolor Total Color 3 Unicolor RP-1000 Chemistry

Your Cost—Before you decide to process and print the photos yourself, calculate the costs carefully compared to sending the work to a good commercial lab. You must be aware not only of the cost of the paper, but the cost of the necessary chemicals and your time involved.

Regardless of what you would be otherwise devoting your time to, your time in the darkroom is worth something. Some people consider time not spent in the darkroom more time to shoot. I can assure you that it is worth a minimum of $10 per hour. If it takes you two hours to make two 8x10 prints, the cost is $10 per print, plus the cost of paper and chemicals. That's high compared to a $3 lab print.

If you're using your time to produce multiple-image prints, which are higher priced when done commercially, you may be saving both money and time. Always know your capabilities and your budget. You never want to cheat the customer—or yourself!

AVAILABLE COLOR PRINTING PAPERS	
Negative-to-Positive	**Reversal**
Kodak Ektacolor 74 RC Kodak Ektacolor 78 Oriental Color Paper RP-II Unicolor Resin-Base Color Print Paper, Type RB	Ilford Cibachrome Color Print Material, Type A Ilford Cibachrome Color Print Material, Type II Kodak Ektachrome RC Paper, Type 2203

AVAILABLE B&W PRINTING PAPERS	
Type	**Brand**
Cold-Tone Fiber-Base	Agfa Brovira Ilford Ilfobrom Ilford Ilfobrom Galerie Kodak Azo Kodak Kodabromide Kodak Medalist Kodak Polycontrast Kodak Polycontrast Rapid Luminos Bromide Oriental New Seagull Unicolor Baryta Base Unicolor Exhibition B&W Paper
Warm-Tone	Agfa Portiga Rapid Kodak Ektalure Luminos Portrait Paper Oriental Center
RC	Agfa Brovira 310S & 312S Ilford Ilfospeed Ilford Ilfospeed Multigrade Kodak Kodabrome II RC Kodak Polycontrast Rapid II RC Luminos Bromide RD & S-ST Oriental New Seagull Resin-Coated Type Paper Unicolor Resin-Base B&W Paper

SHOWING PROOFS

Whether the proofs are contact sheets, 3-1/2x5 color prints, or slides, once they are ready you should make an appointment with the bride for her to view the proofs. The ideal way to show proofs and take the print order is to do both at the same time. If possible, ask the bride if she can notify other people who might be interested in viewing them. Make a party of it if you must, but try to get as many people as possible involved.

Try to show proofs as soon as possible after the wedding, while the thrill still lingers. This is another good reason to work with a lab with reliably fast service.

Slides as Proofs—You must give careful consideration to showing slide proofs. Of course, a slide projector is necessary. If you show the slides to a group, first view the edited slides to give the people an overall view of the event. Then go through them again more slowly so orders can be placed. As certain slides are rejected, remove them from the projector tray until only those ordered remain. You will probably find more left in the tray than you expected. Part of the reason is that the large projected image is always more impressive than a small proof print or contact sheet.

Return of the Proofs—If you must leave proofs with potential customers, set a reasonable time deadline for the return of proofs and print order. Your aim is to deliver the finished work to the couple as quickly as possible and be done with the matter.

There is always the possibility of delay when dealing with commercial labs, and if you must wait indefinitely for the proofs to return, you may feel that you will never get the job done.

The time problem is compounded by the number of per-

If you are going to show slides at the bride's home, check to see if she has a screen or white wall. If she doesn't, you have to supply the screen. A lightweight, portable screen, such as the Port-A-Screen will come in handy.

If you need to show slides but don't have a slide projector, a good slide viewer/editor like this Sawyer's model can do the job instead.

sons who must see the proofs. The longer the proofs are floating from town to town, the greater the chance of waning interest and smaller orders. If the family of either the bride or groom lives out of town, allow time for the mail and the procrastination of the people involved.

The customer can neither be rushed into selection, nor allowed to take too much time placing the order. It may happen that you never see bride, groom or proofs again. In this case remember to be a bit more aggressive next time by setting a time limit and checking occasionally, tactfully of course, as to how things are moving along. If the proofs vanish anyway, keep the negatives or original slides and use them as samples.

Regardless of the time necessary for the selection process and resulting order, be ready for your next step. Have the commercial lab already chosen, or if you are to do the work yourself, have the materials on hand and ready to proceed. The greatest possibility for additional print orders comes with rapid delivery of the initial order.

Additional Orders—One way to encourage additional orders is to deliver the initial order in an album that allows room for extra prints, rather than the type that is bound and accepts only a fixed number. Include a couple of extra inserts in the bottom of the album box, at no charge.

I use a white leatherette album, gold embossed with *OUR WEDDING* on the cover. It is an 8x10 inch album that easily holds inserts for as many as 50 prints.

You can also consider the proofs as an additional order. Depending on the circumstances, you may give the proofs as a gift or sell them at a flat rate. It is possible that the price of the proofs may cover the cost of the film, processing and proofs. Don't be greedy, though. The proofs aren't worth more than about $35.

If you used slide film, you can sell the original set, a duplicate set, or both. If you sell the original set from which the prints were made, consider the price carefully because once the set is sold, you are out of the reorder business. If the contract was for you to produce a set of transparencies, without a print order, you are through with the entire event once the set is sold.

You may get the next wedding assignment based partly on the samples from previous jobs. The sale of proofs will result in higher per-wedding profit, so don't worry about holding on to them as samples. If the couple wants to purchase the proofs, allow them to do so. You will do better to select several outstanding negatives or slides from various weddings, have them commercially printed to a large size, and use them as samples. They are always more impressive than the small machine-made prints.

A professional presentation of wedding photographs in a wedding album often means larger reprint orders. The above photo shows a variety of wedding albums. The large ones hold the 8x10 enlargements ordered by the wedding couple. The smaller albums are ideal for holding the 5x7 print order typically requested by the bride's mother. The bottom photo shows preview books. These are ideal for showing proof prints to the wedding couple. You can reuse preview books or sell them along with the proof prints. Photos courtesy of The Holson Company.

4
The Contact and Preplanning

Your initial contact may be the prospective bride, the prospective groom, or a mutual friend. You may receive the contact either in person or by telephone. If the contact is by telephone, arrange a time for a personal meeting. Aside from gathering information about the date and hour of the ceremony, save the discussion of details for the personal meeting.

The first meeting is usually with the bride-to-be. Rarely does the prospective groom attend. You will likely not even meet the groom until the wedding day. It's not necessarily because he's disinterested, it's just that most brides assume the responsibility for the photographs.

You may have been contacted for a number of reasons. Either she has seen and appreciated your previous work or has been told of it by a friend or relative. Therefore, she is comfortable assuming that you offer a quality product. Remove any doubts by bringing some samples of previous work. Now she must determine whether or not your work is affordable, as well as how sensitive you will be toward one of the biggest days of her life. These are all legitimate concerns on her part, and it is your responsibility to provide the answers she seeks.

WHERE TO START

Knowing that she expects the highest possible quality at the lowest possible cost from a sincere photographer, how do you begin? First, determine what kind of coverage she wants and tell her what you can do. Then decide if you can handle the assignment and perform adequately. Assuming your calendar is clear for the appointed date and hour and you have confidence in the equipment and your ability to use it well, you should have sufficient reason to expect a successful venture.

But it's still early in the game, and this is the time to act honestly and wisely. If you sincerely believe in your competence, say so. If you have serious doubts, say so. There will always be another wedding and if you feel you are not ready for this one, wait for the next one.

I assure you that everyone concerned will be happier.

If you have the self-confidence and have accepted the job, press on. This meeting is for both of you to gather information. She is aware of the quality of your work and you have let her know you are available at the appointed time. Her concerns will now turn to cost. Let's look at some approaches:

No Charge—You gain experience, and in the case of friends or relatives, the photographs become a sincere and lasting gift.

At Cost—You charge only for your cost of film, processing and printing. You can gain experience and make new friends.

For Profit—All costs are calculated and an additional fee is added for your time and expertise.

Even if you are doubtful about your ability to handle the job well, don't decide to pursue the *No Charge* plan based soley on that feeling. Remember that if you are not sure in the beginning, you should let the job pass. Just because the work is free, the wedding couple will not settle for any less than they expect from you. In fact, some people who get free photographic service can be the most difficult and demanding customers.

The other two options involve some careful calculations, and in the next chapter I'll give you some ideas on pricing. Proper pricing is very important and demands a realistic approach. To avoid bad feelings on either side later, both parties must agree at the start.

Because photographer Diane Ensign-Caughey visited this reception site before the event, she knew that a tripod would come in handy for an available-light photo.

A LESSON TO LEARN

Let me relate an anecdote about the first contact—or rather the lack of first contact. It's not an exciting story, but in telling it to others, I've learned it is not uncommon, even if the details may differ.

When I was preparing this book, a friend mentioned that he was going to photograph a wedding at his church in a couple of weeks. He thought it would be a fine opportunity for me to come along and make any photographs I might want as examples for this book. He assured me the couple wouldn't mind and that I would be free to do as I wanted.

A few days later he called and gave me the details and mentioned that he would be happy to give me a hand with the photography. *Hmm*?

In a few more days he called to let me know he would try to do his best to be there. *Oh, really?*

The day before the wedding his wife called to let me know her husband was having open-heart surgery the next day; however, she would be at the wedding to introduce me to the bridal couple. *Well!*

Because I've had years of experience and it was a small wedding with a lovely couple, everything went smoothly. I've seen photographers excuse themselves at the last moment, but never to such great lengths. He recovered from the surgery, by the way, and everything turned out well.

The story shows what can happen when you least expect it. With less experience on my part, not having the opportunity to make the first contact could have had serious consequences. It can happen to you just as easily as it happened to me. Don't accept the last-minute job unless you know you are capable and can adjust accordingly. Refusing may injure someone's feelings, but I promise you'll be better off in the long run.

Gathering Information—Once you have established that you will accept the job, the kind of coverage you'll provide, the end product and the cost, the bride-to-be will have satisfied her major concerns. Now is the time to begin gathering the information you require. This will begin your pre-planning work, and you need to know the following:

The date of event.
The time and location of both wedding and reception.
Number of people in the wedding party.
The name of the minister, priest, or rabbi.
The need for a bridal portrait for the newspaper and the date of submission.

Photocopy the form on the opposite page and use it to compile this information.

Completing the First Meeting—The first meeting is nearly over and only a couple more items need to be mentioned. You must assure the bride that you will take plenty of photographs of the event and that you are looking forward to being of service to her.

Tell her that she can be very helpful to you by furnishing you a list of *special photographs*, so you can be sure she will have complete coverage of the day.

The list should mention special people, such as visiting relatives and friends, as well as activities that will provide fond memories for both the bride and groom. Ask that the list be given to you at the end of the upcoming portrait.

Be sure to ask for a list of special people the bride wants photographed. You don't want to miss any opportunities to give the bride what she wants. This is good business practice and also shows her that you take your responsibilities seriously.

Opposite Page: Photocopy this form and use it to compile important information.

WEDDING INFORMATION

Bride _____ Groom _____

Address _____ Address _____

_____ _____

Phone _____ Phone _____

Post-Wedding Address _____

Phone _____

Ceremony

Date _____

Location _____

Phone _____

Wedding Official _____

Contact _____

Group Photos _____

Special Photos _____

Other Info _____

Reception

Location _____

Phone _____

Contact _____

Bridal Portrait

Date _____ Time _____

Location _____ Phone _____

_____ Proofs By _____

_____ Prints By _____

Newspapers _____

The Bridal Portrait—You now know whether the wedding is inside or outside, whether it will be a day or evening event, the necessary film, the size of the group you must handle, who is in charge at the wedding location, and more. If a portrait is required for publication, you must make the arrangements for it.

Make the arrangements for the portrait sitting so you have ample time to deliver the finished prints well before the publication date. Because brides are photographed in bridal gowns, select a convenient location where facilities are available for dressing and where the chance of damage to the gown is minimal. Lighting and posing are discussed in Chapter 6.

Whether you are charging a fee for the wedding photographs or not, you may want to provide the formal portrait prints for the newspaper free. Because the newspaper requires b&w prints for publication, your material costs are not great, and the bride will appreciate your thoughtfulness. It's a nice gesture, and it begins the relationship on a pleasant note.

It has become increasingly popular to publish a picture taken of the wedding couple on the day of the ceremony. The picture is published some time after the ceremony, whereas the photograph of the bride alone is usually published on or after the wedding day.

The single portrait is still usually the bride's choice, but by only a slight margin. If the bride prefers a couple picture, try to arrange it *before* the ceremony.

The most common problem with these pictures is a result of

If you are going to photograph the bride and groom together, you may want to try poses like these. Even if you shoot color negative film, you can still make high-quality b&w prints for newspaper reproduction. Photos by Diane Ensign-Caughey.

the age-old custom of the bride and groom not seeing one another in wedding attire prior to the ceremony. Doing so purportedly causes bad luck and the prospect of unhappy years ahead. That means, of course, that the couple-picture must be taken sometime during the ceremony or reception. Apparently this is a severe challenge because the results are usually incredibly bad.

The majority of today's weddings are photographed in color, but it is certainly no great feat to present a high-quality b&w print from a color negative. The secret is to take a photograph specifically for publication after having selected an appropriate location, background, and lighting arrangement. A quick snapshot is not suitable, nor is it worthwhile to try cropping the couple from a group photo. You only have to look at your newspaper to understand the point of this discussion.

If you rely on processing by a commercial lab or even do it yourself, you may run into a time problem. If you have to wait for the lab to return the proofs so the couple has the opportunity to select a picture for publication, a great deal of time may elapse before the newspaper receives the print. Some newspapers have no interest in printing what they may consider old news.

Look at your local newspaper to determine how it handles the wedding announcement photograph. Telephone the person in charge of the department for more specific information.

MAKING A B&W PRINT FROM A COLOR NEGATIVE

If you print a color negative onto regular b&w printing paper, tonal distortion results because the paper is not sensitive to all colors in the negative. The photo at lower left is an example of this.

Eastman Kodak makes panchromatic b&w printing papers to avoid this problem. These are Panalure, Panalure Portrait, and Panalure II RC. The photo at lower right was made with this type of paper. Notice how the photo's tonal rendition better matches that of the color print.

After exposure, these papers are processed like conventional b&w papers. Because both papers are panchromatic, use a #10 amber safelight. Safelight exposure should be minimized. Photos by Bernie Meyers.

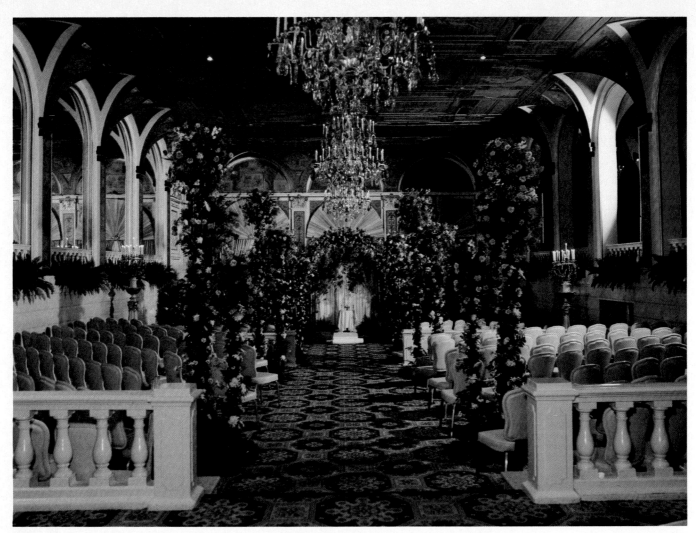

If you visit the site of the wedding ahead of time, you'll be better equipped to handle the assignment. For example, if the location promises to be especially beautiful, such as this one, you can plan to bring extra lights to photograph it properly.

For this location, photographer Steven A. Sint used multiple flashes on both sides of the columns to light the room completely. While he stayed at camera position with a front flash, assistants triggered the side flashes. A photo as successful as this one might also be bought by the chapel or the florist who supplied the flowers. Advance planning can pay off. Photo courtesy of H&H Photographers.

VISITING THE WEDDING LOCATION

An important step often overlooked in preplanning is a visit to the wedding location prior to the day of the event. It is important even if you think you are familiar with the place because the chances are that you have never viewed it from a photographic perspective. It is also worthwhile to spend a few minutes with the person who will perform the ceremony, if possible.

Many churches have someone whose job includes making wedding arrangements, such as reserving the time, helping the bride plan for music, flowers and food, and preparing the reception hall. Telephone the church, ex-plain who you are, and make an appointment with that person. He or she can give you valuable information concerning church rules, safe places for your equipment, and sometimes great picture ideas. Remember that this person has most likely been involved in many weddings and will gladly provide any possible assistance that will make it go smoothly.

As you inspect the location, make sketches and notes of the areas that may work well for the photographs you have in mind, as well as those special ones the bride may want. You need not spend an inordinate amount of time poking about, but a few good notes will make the trip worthwhile. The time spent this way indicates to the person in charge of the arrangements and the person performing the ceremony that you are sensitive to their wishes and ideas. This helps assure you of their cooperation on the big day. Of particular interest are these areas:

The bride's dressing room.
The groom's dressing or waiting room.
The office where the wedding license will be signed.
The location for the group pictures following the ceremony.
The reception hall, if the reception is to be held at that location.

Make notes concerning the lighting and the size of each room. The room size influences the lenses you will need. A great many people in a very small room can make it difficult to use a standard focal length lens. The bride's dressing room may be quite small and will no doubt be filled with people helping on the wedding day, so study the room carefully.

If the reception is to be held at another location, make a visit there also. Once again, make notes on room size, lighting, and backgrounds. If you know what to expect beforehand, your self-confidence and ability will increase.

It will also be to your advantage to make your scouting expedition at or near the hour the wedding will take place if possible. You will then be able to make exposure readings for inclusion in your notes. With advance meter readings, you will be in a fine position to make intelligent decisions concerning the film and lens requirements for any available-light photographs.

A night wedding will offer fewer opportunities for available-light work, but if you are observant, a few good possibilities might be present. Your notes will provide information that will allow you to work quickly and confidently when the moment arrives. Look for areas lit by spotlights. Perhaps there is a stained glass window illuminated from the back, which can be used as background for the silhouetted couple. There may be attractive lighting on the front porch, where the couple can pause for a kiss as husband and wife. Look everywhere, inside and out. An idea is always worthy of an attempt. If the image later proves unsuccessful, remember that you don't show the bad ones as proofs.

Visiting the location of the wedding reception will also help you get the best results. If the wedding party dances, you'll want to photograph them in action, but one on-camera flash won't do the job well enough. You'll need at least three flashes and a bit of planning to light the room well, as was done in this photo. One flash was on camera, one to the left, and the third is visible in the back of the room. The latter two were triggered by slave cells. Photo by Steven A. Sint.

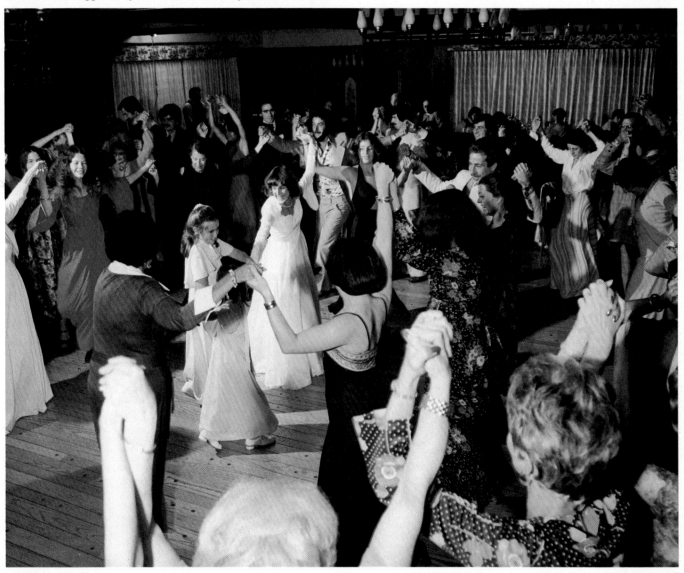

5
Pricing and Cost Estimation

It's difficult to determine where a chapter dealing with prices should be placed. It contains information that you should normally have prior to the first contact with the bride-to-be. However, going on the premise that this is your first wedding assignment, what to do and when are usually of greater importance.

If you didn't get the job, or got the job but didn't get the pictures, prices are of no consequence. But the subject is very important, and you must be as realistic as possible so you can be honest with yourself and your customer.

If you are presenting the photographs at no charge, you should know how large a gift you're giving. If the work is to be done at cost, the customer should know what to expect. If the agreement was made that the work would be done on a professional profit-making basis, other factors are involved. Let's discuss each circumstance with the idea of the results being neither on the long nor short end of the proverbial

stick, but somewhere toward the middle.

WHAT TO CONSIDER

Some of the thinking that goes into a wedding print order is as goofy as any you'll find in the entire field of photography. My business, as well as that of all studios I've been connected with, has been based on standard job and print prices. For example, a standard wedding, including the b&w bridal portrait for newspaper publication, complete wedding and reception coverage and 18 8x10 color prints in an album, has been priced at $220. This price includes some minor profit and is by no means exorbitant. However, two weddings with the same coverage totaled with amazing variance. One cost no higher than the minimum $220, and the other totaled a staggering $2,700. The difference between these weddings will be made clear later.

No Charge—In the case of the second price the studio fully expected additional print orders,

based on early contacts with the bride-to-be. But most often you will have little idea what the total order will be.

This variance in the size of print orders between two basically similar weddings is of importance to you, especially if you are doing the wedding at no charge.

Don't get caught in the position of having to back down on your offer if the order grows unexpectedly. Commit yourself to a specified maximum, such as 12 5x7 or 8x10 prints in an album. Be sure the customer has a clear understanding of the cost of all prints ordered in excess of your offered maximum.

To get a clear idea here, picture

No matter which pricing plan you choose, you should always remember that you are providing a *service* to the bride and her family. Be creative and daring. Make special and unusual photos like this one, but not at the expense of standard photos the bride really wants. Photo by Howard Skolnik.

56

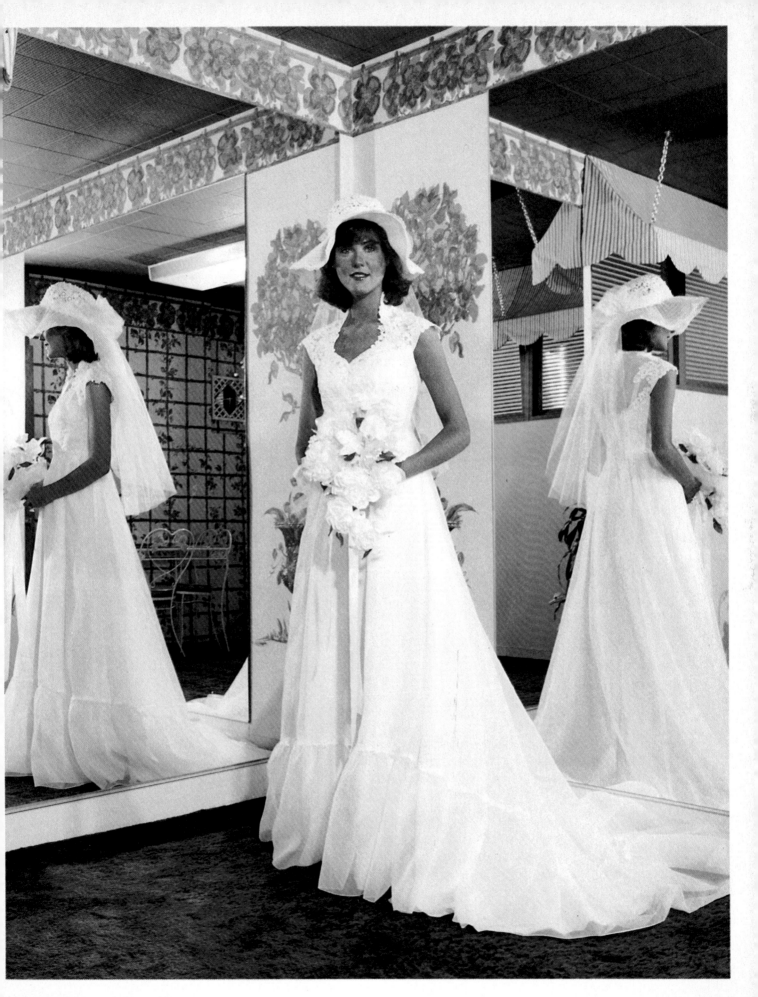

yourself digging into your pockets when facing a bill of $2,000 to pay the custom lab for the gift you're giving Cousin Zelda. Remember that people have a way of taking a couple more of what is free.

At Cost—This is a fairly common practice today for the person who is not a full-time photographer. It's a way to gain experience and help a friend or relative while not incurring any expenses of your own. When doing wedding photographs at cost, it is important that the bride have a fairly accurate estimate of what's involved. As popular as cameras and snapshot photography are today, few people are aware of the cost to produce fine photos of a wedding. The figures may come as a shock to both you and the lady.

Be sure to get receipts for all expenditures and present an itemized statement when the job is completed. Even if you use film you have on hand, it was paid for sometime, and its cost figures in the total. Your word may undoubtedly be enough, but the facts are never out of line.

This method of wedding photography can also be problematic in that there is always the question of whether or not it could have been done cheaper. Should you really have used the lab offering the highest quality at the highest price? Could you have saved something by buying your film at a high-volume discount chain store? Is plastic really inferior to genuine leather in an album cover? Couldn't you have covered everything with one roll of film rather than three? Have the answers by establishing the plan and the agreement beforehand.

INSURANCE

There is liability insurance available for the professional photographer. However, as you probably already know, lost or damaged film is woe to the photographer who owns it, not the film lab or the mail service. They simply send you another roll of whatever film was lost, minus your precious images. This has happened to me on occasion, and it is most frustrating.

Nothing is more embarrassing than going back to the bridal couple and telling them that you failed. It will be interesting to see if liability insurance for this case becomes easily affordable for the amateur. What price can be placed on the loss of the once-in-a-lifetime wedding pictures, and who will decide the amount the couple is to be reimbursed?

There are other types of insurance you might want to consider. These have been available for many years and are important for the financial well-being of many photographers.

The first type of insurance you might consider, for the sake of the client, is a liability policy. This would come in handy when you break the bride's family heirloom, hit Aunt Martha in the face with your flash, or break Uncle Joe's foot when you suddenly step back to get that perfect picture.

Whether you are clumsy or not, people do break things and injure other people from time to time. The proper type of insurance can certainly save you a lot of financial problems. Of course, if you are terribly clumsy and make a habit of this sort of thing, you might have to spend quite a bit of time trying to find an insurance company to cover you.

A second policy that might be more important to you in the long run is a policy to cover your equipment in case of accidental damage or theft. This type of policy is usually known as a *marine* or *floater* policy, depending on the company and how it is added to your coverage. This insurance can usually be added to a homeowner or tenant policy you might already have. The rates and types of coverage vary from state to state, so I will not attempt to quote rates or exactly what the policy might cover in your state. However, merely as an example, my last policy renewal was at a rate of $2.40 for $100 of insurance provided. This is a hobby rate, which means the equipment does not provide more than approximately 40% of my income. The professional rate was about twice as much.

This kind of insurance can save you from monetary ruin if you are making a living from photography and are not in a position to replace equipment that is damaged or stolen. Even if you could afford to replace the equipment, the premium is still much less expensive than the cost of that equipment, so I think it is good insurance to have. Almost any insurance company in the business of insuring personal property can help you out with these items and pass along a few safeguards at the same time, such as marking your equipment for easy identification in case of theft.

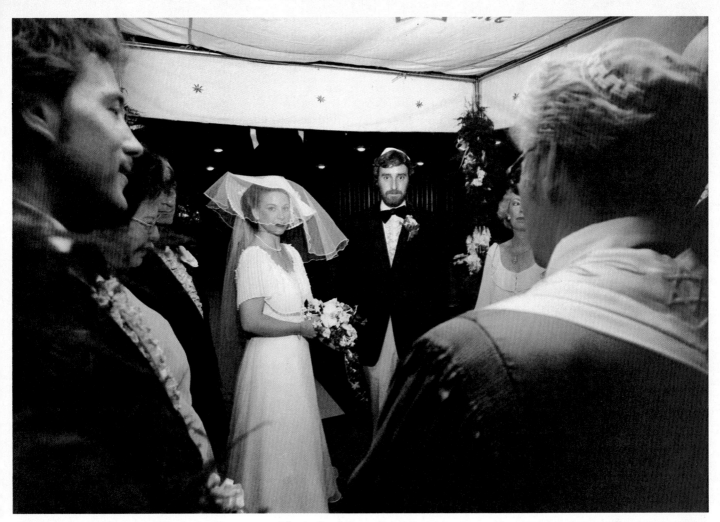

When photographing a wedding for profit, you are *obligated* to deliver photos that are composed, exposed, and presented professionally. Learning to do this takes time and practice, so I think you should shoot for profit only *after* photographing a couple of weddings on a *no charge* or *at cost* basis. Photo by Howard Skolnik.

For Profit—If you are photographing the wedding on a profit-making basis, the entire arrangement differs from the other two cases. You may be working for a stranger, or at least no one closer than a friend of a friend. This is strictly a business transaction and must be treated as such.

By accepting the assignment, you are expressing confidence in yourself to function professionally. If your behavior and photographs are not at such a level, you will probably never have a chance to redeem yourself in the eyes of the wedding couple, their families, or their wide circle of friends.

Acting in a professional capacity includes several responsibilities. You are obliged to adhere to the business regulations prevalent in your area. This usually means a business license, collecting sales tax on merchandise sold, and forwarding the tax collected to the appropriate city and state agencies.

As a practicing professional, it is necessary for you to perform your work with the customer's wishes uppermost in mind and to deliver full value for each dollar received. Don't get the idea that because you get a profitable fee for your services that you can get away with delivering a sackful of hastily taken snapshots. On the contrary, your photographs should reflect the highest possible care and quality. They will be judged with those expectations in mind.

If, as many studios do, you draw up a contract with the bride obligating her to purchase a minimum number of prints and request a deposit equal to the cost of the minimum number, you can feel assured that your minimum profit figure has been met. This contract is, of course, binding on you to produce that number of prints.

If through some error on your part or on the part of your agents, such as a commercial lab, you are unable to produce the contracted prints, you are liable for legal action in civil courts. Before you accept a wedding assignment as a business transaction you should know what's involved. Be prepared to handle the situation in a professional manner.

CALCULATING COSTS

Whether you choose to work at no charge, at cost, or for profit, you must be aware of the costs involved. Let's start at the beginning and go through the whole process.

The first cost you'll encounter is at the time of the bridal portrait. Cost includes film, material for proofs, and for the finished publication prints. Although prints for the newspaper will be b&w, you might want to do the photographs on color film, allowing you to offer color enlargements at a later date. The cost of color is, of course, usually higher than b&w, but the sale of a print or two here more than offsets the difference.

The next cost comes about as a result of preparing for the wedding itself. This includes not only the necessary film for complete coverage of the activities, but such things as new batteries for electronic flash units or a new tie to go with your blue suit. The tie, however, is not an item you can charge to the customer!

Complete coverage results in the exposure of 70 to 100 pictures. If you are using 35mm film, this means three 36-exposure rolls. However, to be safe, always arrive with twice the amount of film you think you'll need.

Then comes the costs of film processing and printing. Enlargements follow the selection from the proofs, and these go into an album.

SOME NUMBERS

Let's consider some typical figures for a normal situation in which you send processing and printing work to an average-priced commercial lab. If you are using color negative film for complete wedding coverage, you find this:

Bridal Portrait

1 roll Vericolor II film, 20 exposures	$ 3.08
Processing	1.85
Proof prints 2R (2-1/4x3-1/4), 20 @ $.27	5.40
B&W prints for publication, 2 @ $.90	1.80

Wedding and Reception Photographs

6 rolls Vericolor II, 36 exposures, @ $4.33	$25.98
Processing, 3 rolls @ $1.85	5.55
Proof prints, 3R (3-1/2x5), 108 @ $.35	37.80

Enlargements

18 8x10 Ektacolor prints @ $4.85	$80.10

Album

8x10 with sleeves for 18 prints	+ $11.55
Total	$173.11

Pretending that $1.89 will cover gasoline, coffee breaks and frayed nerves, let's round up the figure to $175. This is quite a generous gift at no charge, or a shock to the bride who agreed to the at-cost plan and expected you to charge $35 to $40. This is also an interesting situation for the profit-maker who, at first glance, was prepared to bid the job at $125.

Of course, it can all be done for less. Perhaps you get the materials and service at a discount, especially if you hold a local business license. There are mail-order labs that specialize in wedding work, providing 8x10 color prints at $1.00 each on a package basis when printed at the time of film processing.

A less expensive album may be available by ordering through your local camera shop. If you're already set up to handle the processing and printing yourself, this can also be a saving, providing you remember to include $10 per hour for your time.

I can't possibly cover each path open to you regarding costs. I have given you a typical situation to show how to calculate some fixed costs. The prices shown here were valid when I prepared this book. They may be different later.

Remember that the quality of your work is only as good as its poorest element. Poor-quality negatives and transparencies will produce poor-quality prints. It's silly to go to great pains to carefully expose film and then have it processed and printed by a friend down the street because he works cheap by doing it in his backyard after sundown. Once you begin the job in a quality fashion, see to it that it is completed in the same manner. Give people what they pay for.

I've found that people do not mind paying a fair price for quality work. They will mind, however, if you give them less quality than they expect. It is your responsibility to see that *every* phase of the job is done with high-quality results in mind. Photo by Diane Ensign-Caughey.

PAYMENTS, PROFITS, AND EXTRA SALES

During the first contact, or at the time of the bridal portrait, be sure you receive a deposit for the number of pictures you are asked to produce. I suggest you get at least 50% of the price you are charging for the album package. In fact, 75% is even better.

I'm opposed to asking for the entire amount at this point because I find it tends to cut of the sale of additional prints. If the total bill has been paid before the proofs are delivered, the couple may be so happy not to be indebted to you that they won't allow themselves to renew their spending by increasing the order. If only a small portion of the charge is still outstanding, it seems much easier for them to add to the order.

I think that financial arrangements should be made early in the agreement and completed when the enlargement order is placed with you. The wedding day is not an appropriate time to play the role of bill collector, although many photographers do just that.

Waiting for payment until the finished prints are delivered is also a poor plan. At that point, sufficient time has elapsed for the grand rush of enthusiasm to have slowed considerably. With the passing of time and the arrival of other bills, you may discover that your bill is put near the bottom of the stack to be paid when things are better.

If you have worked at no charge, or at cost, you've probably delivered the album and gone back to photographing landscapes and butterflies, which is where your interest was before you got involved in weddings. But don't rush out too soon, because we're going into the money-making end of the business now.

Chances are that you enjoyed this first experience and would like to try one for profit. If so, let's see where you find some profit and extra sales. Again, I'll use figures in effect at press time.

Other Sales—In addition to the figures I've decribed, there is a number of other sales possibilities. These include:

Second mother's album @ $100.
Prints for wedding attendants @ $7.50.
Prints for grandparents @ $7.50.
Prints for parents of flower girl and ring bearer @ $7.50.
Prints for florist—1 free, 1 additional @ $7.50.
Prints for caterer @ $7.50.
Prints for the aunt who made the bridal gown @ $7.50.

There is also the possibility of speculative prints. With a little forethought, making prints on speculation can pay off. If you used color film for the formal portrait, consider making a framed 16x20 print. A framed 11x14 print of the couple at the altar might also sell. These can be color prints or a *photo oil*, which is a b&w print hand painted with oil paints to simulate a color print.

THE FULL BILL

It's wise to establish a set package of wedding photographs in the beginning because this is what most people want. Let's say that you offer complete wedding coverage—two b&w formal portrait prints for newspaper publication, 75 to 100 proof prints in color and 18 8x10 color enlargements in an album—for $240. A mother's album of the same 18 prints in 5x7 can be offered for $100, after the purchase of the bride's 8x10 album. Make additional prints available at $7.50 each for 8x10 prints and $3.50 each for 5x7 prints.

Charge

1 8x10 wedding album	$240
1 5x7 mother's album	100
6 8x10 additional prints	45
10 5x7 additional prints	+ 35
Total	$420

Costs

1 8x10 wedding album	$175.00
1 5x7 mother's album	37.50
Additional 8x10 prints, 6 @ $4.45	26.70
Additional 5x7 prints, 10 2 $2.20	+ 22.00
Total	$261.20

Net

Charge	$420.00
Cost	- 261.20
Net	$158.80

If your time is worth at least $10 per hour and you spend six hours from the first contact to delivery of album, calcuate your profit:

Net	$158.80
Less time spent	- 60.00
Total profit	$ 98.80

Depending on whether you wish to think of the cost of your time as profit or return on investment, you have made a net profit of $98.80 or $158.80. This is not too bad for someone who is technically a nonprofessional.

A picture presented to the caterer for free may prove to be worth the investment because he is able to steer more business your way.

Six additional print sales are represented in this single photograph.

Don't offer or suggest the larger work before it has been done, and don't mention price until the work is presented. Once a large print is seen, it usually sells itself. Don't be afraid to quote the price when asked. If the customer hesitates, offer to spread the cost over several payments. Make the work easy to purchase and it's sold. I assure you that the customer wants the work and will buy it if possible.

A photo oil in 16x20 should cost the customer $175 to $200, in which your cost for the print and colorist is tripled and the frame is at your cost times five. Color enlargements are priced at your cost tripled, plus your frame cost times five.

The photo oils and color enlargements are especially good for increasing the total sales when dealing with a wedding that would otherwise only buy your minimum package. At first it appears contradictory, but a bride on a tight budget may be one of your better-buying customers. This is particularly true with the more expensive prints if they're well-presented and offered with an easy payment plan.

There is a bit of psychology at work here. The thrifty bride will balk at spending an additional $150 for extra 8x10 prints on the basis of the quantity involved.

However, a single large print or oil of outstanding quality, offered on easy terms at $175, will be too much temptation to resist.

The desires of the groom enter here also. His interest in the smaller album size prints is usually far less than that of the bride. Ordering prints in addition to those in the album package plan will not excite him much. But he won't let a large, well-done, framed portrait of his new wife slip through his fingers if he can possibly help it. Together, they've

given you a ready-made sale.

Naturally, there is the couple whose heads rule their hearts and decide not to buy the larger pieces. In this case, simply state that you will use the photograph as a sample, and it will be available if they want to purchase it at a later date. Don't be surprised if their financial status has improved before their first anniversary and they come calling, cash in hand.

Be sure that the parents also have a chance to see your speculative work. The only thing better

Unlike the wedding album, a large color enlargement or photo oil is usually hung on the wall for all to see. Many people want them, and I think the best way to discover this is to do it on speculation.

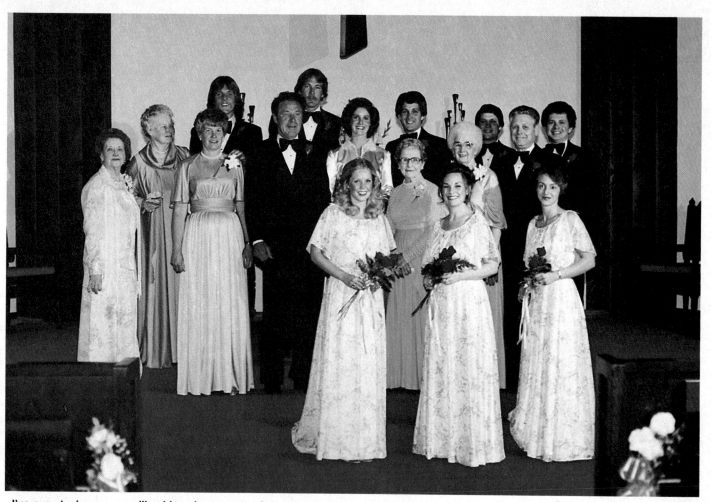

I've even had success selling big enlargements of the large wedding group posing at the altar. The more people in the photo, the better chance you have of making multiple sales. Be warned, however, that big enlargements look good only if they are made from well-made negatives. Take the extra time necessary to precisely compose, focus and expose.

than selling one large print is selling two or three. I've been successful working on speculation with large prints of three particular types of photographs—the bridal portrait, the bride and groom at the altar, and the large group of bride, groom, parents and attendants at the altar.

The $2,700 wedding I mentioned earlier is definitely a rare occurrence. It was the largest I've been connected with and was an example of the ideal situation—two wealthy families, a large guest list, many pictures well-taken and well-presented, and a large number of big prints made on speculation. Of course, all of this was coupled with excellent selling

technique and good photos.

I've been suggesting that you make large prints for speculation because it's a very successful method of increasing sales. But heed this warning—Don't make and present more than two or three prints in this manner. People want these prints, but if they are shown more than three, the selection becomes quite difficult and nothing extra will be bought. It's easy to present too much of a good thing. I usually present no more than the one print that I'm sure will sell.

Proofs and Negatives—You might want to follow the trend toward offering the proofs for sale. Assuming you have about 100, a

reasonable price is $25 or $35. You can see that this price is less than your cost, but remember that you included that cost when you priced the package. You've already been reimbursed.

The couple will nearly always want to have the proofs to keep in a scrapbook or give to friends and relatives. Don't mention that the proofs are for sale until you have completed all of the orders for enlargements. If you do, you'll invariably find they order fewer large prints. If you are concerned about reduced sale of enlargements, you might want to hold onto the proofs to be used as samples when requests for photos come from other couples.

The negatives present a slightly different problem because there is a question of ownership. There are two lines of thought here. The law states that when you are hired to provide photographs, the negatives are the property of the client and may be used in any way he or she sees fit—unless there is a written statement to the contrary.

The tradition is that the photographer retains custody, if not actual ownership, of the negatives and is allowed to furnish additional prints at additional charge later. The photographer may furnish the additional prints to the original client only.

This is not a simple subject and I can't provide clear guidance because my research shows that the courts may decide the question either way. Some view the law strictly, while others tend to think that by relinquishing the negatives, the photographer is deprived of future earnings from that particular job.

Whichever view is taken, however, it appears that the photographer is reasonably entitled to extra compensation if the client demands the negatives. How do you calculate that compensation?

As with nearly everything else in this book, I can only give you an opinion based on my experience. I release the negatives for the price of the film plus commercial processing costs, doubled. I am seldom asked for the negatives but if I am, I explain to the client before I release the negatives that because my business is photography I am better able than he or she to protect the negatives from loss or damage. It is a true statement and is usually respected. Remember, though, that if you do keep custody of the negatives, you can't use them for any purpose without the client's permission. This includes prints made as samples.

ONE LAST WORD ABOUT PROFITS

Before we leave the financial end of things, I'm going to give you some homespun philosophy—*Don't let greed get in the way of your success.*

The sales areas I've outlined are designed to increase your potential profits as you serve the people involved. Do not use these ideas to push the couple into overextending their financial resources. A bride pressured into spending more than she can afford for photographs, flowers or food will soon realize it and feel she's been cheated. She'll spread the word like wildfire.

If you push her into what she feels is financial ruin, you'd better go back to photographing butterflies because you'll never see another wedding through your viewfinder if she can help it.

Your job at the wedding is to provide a service much desired by the bride, groom, and their families. You are entitled to make a *reasonable* profit while performing that service. No single wedding will bring you fame and fortune. That's achieved by providing continued, quality service at a reasonable price, while allowing a reasonable profit.

6
The Bridal Portrait

Making the bridal portrait is a most important part of wedding photography. It is the first time the bride works with you and your camera. Therefore, work efficiently and professionally to remove any doubts she may have about your abilities. Photo by Kathy McLaughlin.

By this time you have visited the wedding location and are satisfied that your equipment is adequate and ready. It's time to consider the bridal portrait. This is an important occasion because it is the first time you will actually be working with the bride-to-be. It's important to her because it is through this photograph that she publicly announces the change in her life.

You must be prepared and ready to work when she arrives for the portrait. If you appear to be unorganized, her confidence in your ability to perform well on the wedding day may decrease.

If you are prepared and are able to work easily and smoothly, she will surely be comfortable in knowing that she has made a wise choice when she selected you as her photographer.

Mention that you have already been to the wedding location and met with the person in charge. This will help convince her of your interest. A pleasant experience at this sitting will remove any of her doubts and assure her cooperation later on.

THE INDOOR PORTRAIT

I strongly suggest that the portrait be done indoors, rather than outside. The lighting is simpler and easier to control indoors, but the most important reason concerns the problem of the bridal gown. You can be sure it was expensive. Because the bride intends to wear it only once, it must be in perfect condition.

This means that on the wedding day there should be no grass stains on the hem or rips in the train. When she arrives for the portrait, she will probably have just picked up the gown from the bridal shop, and the fitting may not even be complete. It is your responsibility to help insure that no harm comes to the dress. An indoor sitting makes that responsibility easier to fulfill.

A changing room of some sort is necessary. The room must be private, of comfortable size and, if at all possible, should have access to running water. A wall mirror should be available—the larger the better. If the gown is floor length, cover the floor with sheets so that the hem and train are not soiled during dressing.

Getting into a bridal gown is usually a two-person event, so the bride will usually bring someone along to help. She may bring her mother or another female member of the wedding party. This is good for you too. The more people you meet beforehand, the more comfortable you will be on the big day.

Dressing is not an instant process, so you are going to find yourself with some time to spare. Double-check everything now. Turn the lights on and calculate the exposure reading once more. Use these few minutes to be sure everything is ready and in place.

Basic Lighting—Basic portrait lighting requires only a few simple steps and not a great deal of equipment. Two properly placed tungsten lights are adequate. When I discussed the two-light system for wedding photography earlier, I described the *main* and *fill* lights. We are going to work with these lights again, this time to produce a studio-type, formal portrait.

When you use one main light for the portrait, shadows are too dark and unappealing.

68

We are used to seeing light as it falls from the natural source, the sun. Sunlight falls on an object from a single direction. The side of the object opposite the sun receives no light, other than reflection, so it is in shadow.

When lighting a subject indoors, our usual aim is to recreate the sun and shadow relationship. When we do, we have patterned the light in a natural way for a comfortable effect. Because the portrait is of a young lady for newspaper publication, you don't want a dramatic character study, but rather an exposure with clear highlights and soft, open shadows.

LIGHTING RATIO AND BRIGHTNESS RATIO

Lighting ratio $(R) = \dfrac{M}{F}$

Brightness ratio $= \dfrac{(M + F)}{F} = \dfrac{M}{F} + \dfrac{F}{F} = R + 1$

HOW TO SET UP FOR FILL LIGHTING

Lighting Ratio (R)	Brightness Ratio	Distance Ratio (L)	Exposure Difference (Steps)
1:1	2:1	1.0	1.0
2:1	3:1	1.4	1.6
3:1	4:1	1.7	2.0
4:1	5:1	2.0	2.3
5:1	6:1	2.2	2.6
6:1	7:1	2.5	2.8
7:1	8:1	2.6	3.0
8:1	9:1	2.8	3.2

BRIGHTNESS RATIO AND EXPOSURE

Brightness ratio is important because it enables you to achieve a desired effect or mood in the photograph, as well as providing sufficient contrast control so the highlight and shadow areas of skin tones are within the capabilites of the film you use. The ratio is expressed as the relationship between highlight and shadow, as shown in the accompanying table.

Arranging a particular ratio is a simple matter when you are working with tungsten lighting. First determine the position of the main, or key, light to get the most pleasing combination of light and shadow. Assuming the fill light is the same type of source, place it farther from the subject than the main light. The table gives the factor L, which, when multiplied by the main-light distance, gives the location of the fill light.

You can determine the brightness ratio with a standard exposure meter, either incident or reflected type. An incident exposure meter measures the light falling on the subject. When using it, hold it at the subject's face and direct it toward the camera lens. Turn on both lights and note the meter reading with the meter in the area lit by both lights. Then meter the area lit only by the fill light. Note the meter indication. The difference in exposure steps between the readings is related to the brightness ratio. See the table. Adjust the fill light to get a 3:1 brightness ratio.

A reflected-light exposure meter measures the light reflected from the subject. Aside from direction of the meter, all the above instructions for the incident meter are the same. Aim the reflected-light meter at the subject while calculating the difference between the two readings. Use a Kodak 18% gray card to meter from, rather than reading directly from the face. Hold the gray card as near the subject's face as possible with the gray side facing the lights, and meter the reflectance. Take care that the meter itself does not cause a shadow on the gray card.

Establishing light ratios with electronic flash must be done by tests or with a flash meter. When making test exposures, be sure you keep detailed notes concerning camera exposure settings, flash placement and flash-to-subject distances.

Here is a simple procedure: If you are using two identical units at equal distances from the subject, placing a single thickness of white cotton handkerchief over the face of one unit will provide a workable and pleasing light ratio for color film.

For this photo, the fill light was added to the setup to fill shadows. However, the light is too close to the subject, creating a 1:1 lighting ratio. The lighting effect is flat.

The main light should be placed approximately 45° to the side and above the lady's face. This light provides the light and shadow areas necessary to give the face some form and modeling. The shadow created is rather unattractive, so the second light is placed to brighten the blackness. The fill light should be as close to the camera as possible and at or very slightly above lens level. Place the fill on the opposite side of the camera from the main light.

Suppose the key light puts twice as much light as the fill on the subject. This creates a *lighting* ratio of 2:1, and the subject has a *brightness ratio* of 3:1. This is the ratio of the light reflected from the subject—where the lights overlap—to the dimmest reflected light where only fill light illuminates the subject. Brightness ratio is what you and the camera see when looking at the subject.

For the formal portrait, I suggest creating a brightness ratio no greater than 3:1. Most newspaper reproductions leave much to be desired, and photographs with higher contrast don't reproduce well. The newspaper wants a pleasing portrait of a pretty, happy girl. This is best achieved using simple, nondramatic lighting. If you are

70

Moving the fill light farther back created a 2:1 lighting ratio, which gives the subject's face more form and depth. The result is a much more appealing photo that is fine for b&w newspaper reproduction.

using lights of equal intensity, do this by moving the fill light backward away from the subject, covering it with diffusion material, or by *feathering* it. Feathering means to turn the light toward the camera so that the subject is lighted with the edge of the light, rather than the bright center of the beam. Be sure to feather the light toward the camera. If it is turned away from the camera and the subject, there is a chance that a dark edge will show on the face where the light beams separate.

Practice on a volunteer until you are comfortable with the setup. This will allow you to place the lights before the bride-to-be arrives. When she is ready, you will be too, with only slight adjustments required for best results. You can use either tungsten bulbs in reflectors or electronic flash units.

The major disadvantage of flash is that the small hand-held or camera-mounted units are not equipped with modeling lamps, so you will be unable to see the light pattern before exposure. If you have practiced long and hard and have kept detailed notes and diagrams, you know exactly what will happen when the flash units are triggered. If you don't have this experience or flash units with modeling lamps, I recommend tungsten lighting.

The position of the fill light is most important in the bridal portrait. As shown in the accompanying diagram, the fill light is not as close as possible to camera position. This creates double shadows on the neck and face, giving an unacceptable portrait.

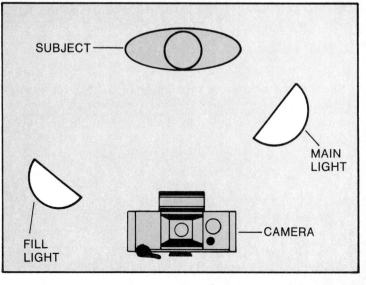

SUBJECT

MAIN LIGHT

FILL LIGHT

CAMERA

Generally, a white background reproduces as light gray when you use only two lights as I've described. If you want the background tone to be lighter, you need a third light, called the *background light*, in the setup. Place the light behind the subject and point it at the background.

I recommend you use a black background when using two lights because it will give a more contrasty look to the photo by helping to offset the bride's white dress and veil.

Backgrounds—Using only two lights does present a problem. The problem is to keep the shadow of the subject off the background. If you have another light available, place it on a low stand behind the lady and direct it slightly upward toward the background. That's the preferred setup.

To keep the arrangement simple, however, I've discussed the two-light plan, so let's stick with it. If you don't have a third light, there are three ways to eliminate the shadow from the picture area.

First, you can seat the subject on a high stool, raise the lights ap-propriately and keep the camera slightly below her eye level. Because the lights are high, the shadow is thrown low and will not appear in the picture area.

Second, if the background is wide enough, move the subject as far from it as possible. The shadow will fall on the floor behind the subject rather than on the background. Obviously, avoiding any shadow on the background requires a great deal of space. You should always use all you can.

The third and easiest way to eliminate background shadow problems is to use background material that is dark and reflects little or no light. Black backgrounds reproduce relatively well in newspapers and will not compete with the fine detail of the bridal gown.

Dark gray backgrounds, although suitable for photographic prints, have a tendency to print muddy and blotchy in all but the very finest newspaper reproductions. Before you decide on background material and color, check the photographs printed in your local newspaper. It will be readily apparent which background reproduces best.

At the Bride's Home—Sometimes you will find yourself working with a lady who wants the formal portrait done in her home. I recommend you try to discourage this if possible. The advantages are that there is much less chance of damage to the gown because she won't have to transport it around town and she can take all the time she likes in dressing so she can be ready when you arrive.

The disadvantages are that you must haul your equipment, including lights and stands, to her home. In addition, there may very well be more people around than you really need to deal with at the moment. Mom, dad, brother, sister, grandma, and friends may all be underfoot and prepared to pass along advice you don't really need. If you are not used to such situations, you will find it difficult to retain, or even obtain, the control you need.

It can also be difficult to find a suitable location with a workable background and adequate space for lighting equipment. There are occasions, however, when the parents' home may offer desirable photographic elements, such as a lovely garden setting.

If you must, or decide you'd rather use the bride's location, make sure you check it prior to the day chosen for the portrait. Be prepared and have a plan. This planning session should be brief, but it allows you to arrive at the appointed time knowing what to do and how to do it.

When the equipment is set and the bride is ready, ask the family to excuse you and the bride for the necessary time for the photograph. Explain that to do the best possible

You will often be asked to photograph the bride in a garden setting. Whether you think it will make a nice photo or not, you should respect her wishes and do the best job you can. Photo by Steven A. Sint for Glenmar Photographers.

job you must have the bride's full attention. When put in those terms, the room always clears because no one wants to be responsible for having been the cause of a less than successful portrait.

When working in the bride's home, be receptive to her wishes regarding the background. If it's her family home where she grew up, she will probably be leaving it after the wedding and certain spots may hold great meaning for her. A beautiful fireplace or corner of a garden may not strike you as ideal for your purposes, but if that's her wish, make her happy. A location you would not choose on your own may prove good in the finished print. Pictures with meaning to her are pictures she will buy.

A portrait of both mother and daughter is always worth making when you are at the bride's home. Photo by Steven A. Sint for Glenmar Photographers.

Be aware of busy backgrounds. If you have no choice or control over the background, control the zone of sharp focus so the background becomes blurred. Photo by Steven A. Sint for Glenmar Photographers.

THE OUTDOOR PORTRAIT

Keep in mind that the greatest chances of damaging the gown come when working outdoors. Still, you may have a good reason to use an outdoor location. If so, remember to keep the gown out of the dirt and avoid the possibility of grass stains. Keep away from branches or anything else that can catch and tear the fabric.

As with any outdoor portrait, direct sunlight is usually not ideal. It can cause deep shadows and wrinkled foreheads from squinting eyes. Bright, open shade is most always a flattering and comfortable location. Of course, this can also create a couple of problems.

The first problem is color. When photographing a subject in the shade, a photograph in color will invariably be slightly blue. This happens because light falling on the subject comes from blue sky, which has a higher color temperature than direct sun.

The second problem is exposure if the background is not also in shade. When the subject in the shade is properly exposed, the background will be grossly overexposed if it is lit by direct sunlight. If the sunlight exposure is accurate, the subject in the shade will become nearly a silhouette due to underexposure.

The solution to either problem is the same—additional light on the subject, either to increase the subject illumination or to correct color balance. Additional light can be provided by reflector or flash. Let's look at the techniques for both methods.

Exposure for this photo was made for the background area lit by the sun. The main subject in the shade reproduces too dark.

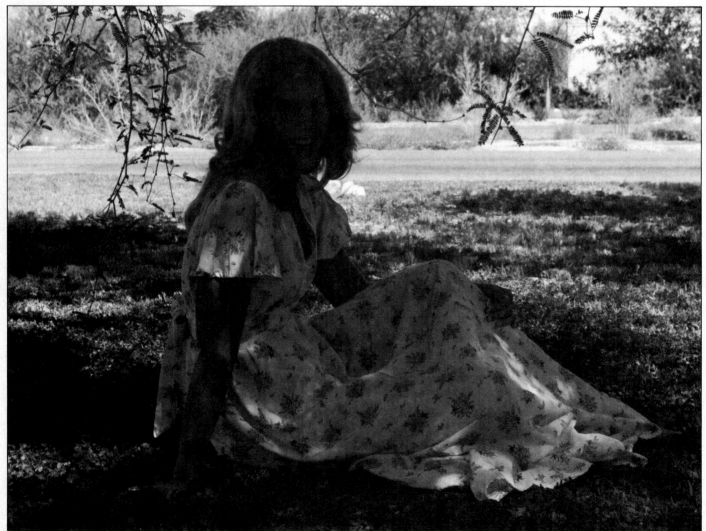

THE SUNNY-DAY *f*-16 RULE

Remember this rule and you'll be glad you did the day your exposure meter fails or you want to doublecheck an exposure reading.

For subjects and scenes illuminated directly by the sun on a bright sunny day, shutter speed is the reciprocal of film speed when aperture is *f*-16.

Example: You are using ASA 125 film on a bright sunny day. Set aperture to *f*-16 and shutter speed to 1/125. If you are using ASA 32 film, you want a shutter speed of 1/32. The nearest marked speed is 1/30 and that's close enough.

When exposure is adjusted for the main subject, the background washes out and loses detail. This may be OK if the background is unattractive.

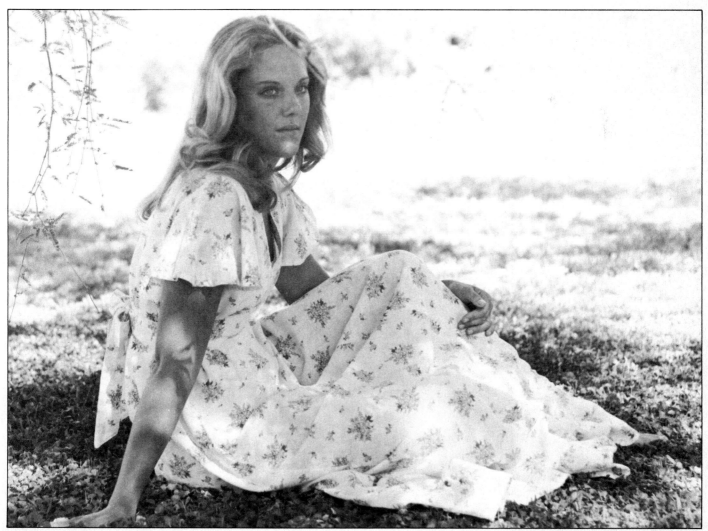

Direct sunlight is harsh, contrasty, and uncomfortable for the subject.

Turning the subject's face a bit and bouncing some light into it with a reflector helps make the portrait better.

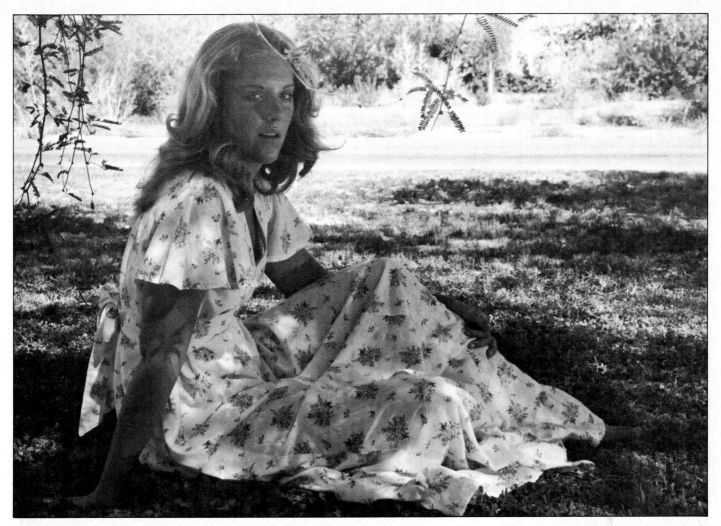

For this photo I exposed for the sunlit areas and bounced additional light into the subject's face with a reflector. It was placed too low and created unappealing facial shadows. Improper placement of fill light is a common problem you must be aware of.

Reflectors—Reflector material can be found in any good photo store. Poster board with a smooth white, silver, or gold surface is suitable. I prefer the gold matte surface because I like the warmth it gives skin tones.

The most practical way to use a reflector is to adjust color balance when photographing brides. Increasing the light level in the shaded area to approximate that of the background sunlit area requires so much reflected light that the gold tone becomes overdone and objectionable. In this case, you have only substituted a warm tone for a cool tone.

Usually, I let the background burn out and keep the reflector far enough away so that the amount of reflected gold is just enough to eliminate the normal but unwanted blue. The only time this does not work well for me is when I'm photographing a subject in more than three-quarter length, which may necessitate a very large background area. A large, bright background takes away too much attention from the main subject.

When using the reflector, remember that it is a directional light source that is brighter than the shaded light on the subject and will create its own shadows. I think the single biggest problem photographers have in using reflectors is that the board is held too low, causing the light to be thrown up at the face. The resultant shadow pattern resembles something you might see in an old horror movie. You can bet the bride won't buy many of these. Keep the reflector as high as the main light in an indoor setup.

Reflectors are portable, inexpensive, and reliable. However, they can be unhandy on a breezy day and less effective on cloudy days. They also often require an assistant to hold them if you don't have a sturdy stand.

Flash—Although reflectors are certainly suitable in most cases, flash provides almost complete control over both color balance and exposure, with the flash used to fill in the shadow areas around the subject.

The first step is to determine the guide number (GN) for the film and flash combination you are using. If you're lucky, it will be noted in the flash manual. If not, use this method:

1 Set the calculator dial on the flash to the proper ASA rating of the film you are using.
2 Note the *f*-number opposite the ten-foot index mark.
3 Multiply the *f*-number by 10. This figure is the guide number in feet for this film and flash combination.

Example:
Kodak Kodacolor II film: ASA 100
Flash dial set at ASA 100
Dial indicates a setting of *f*-16 at 10 feet: 16 x 10 feet = 160 feet. The GN for Kodacolor II with this flash is 160 feet.

Now that you know the guide number, you can begin an exposure determination for the scene. The bride is sitting in the shade of a lovely tree. Behind her is an expanse of beautiful green lawn, dotted with flowers and more trees. You know that if you expose for the bride in the shade, the lush background will be overexposed, washed out, and lacking detail. The problem is to adjust the light level so the shaded and sunlit areas reproduce equally well on the film. Because it's impractical to dim the sun, we'll brighten the shade instead.

1 Take a meter reading of the sunlit area as if it were to be photographed alone.
2 Set the lens aperture to the *f*-stop to give correct exposure with the shutter speed that synchronizes with the electronic flash, based on the meter reading in step 1.
3 Set the camera in position to photograph the bride.
4 Divide the guide number by the *f*-stop obtained in step 2. This figure should be the distance in feet, from the bride to the flash.
5 Place the flash at that distance and expose the film.

By using a sunlight exposure based on the background and electronic flash fill for the subject as described in the text, I could get a better balance between the two.

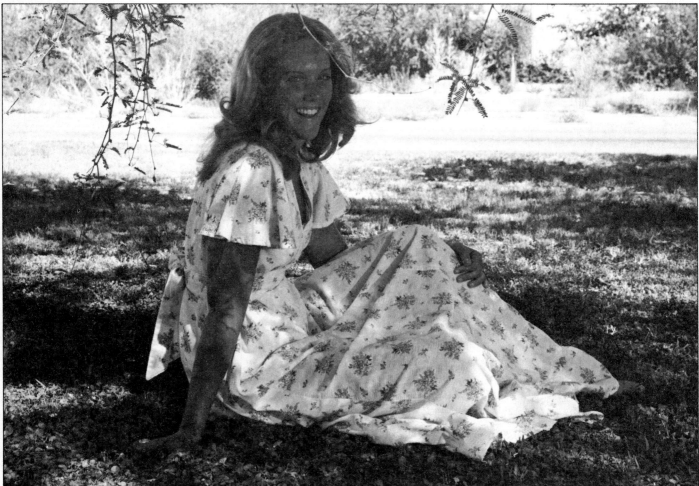

Example:
Sunlight exposure reading: 1/60th second at *f*-16.
Calculate: 160 feet/*f*-16 = 10 feet.
Flash distance: 10 feet from the bride.

Because you have no walls or ceilings outdoors to reflect and redirect the flash light, the guide number calculation will give about one step of underexposure from the flash. This gives a lighting ratio of about 2:1, with the sunlit area twice as bright as the flash area. This is a very attractive ratio and, as a matter of fact, anything closer to 1:1 appears unnatural. After all, the bride is in the shade and this is the feeling you want to keep.

You've accomplished two things now. The light ratio between the sun and shade has been compressed and is well within the capabilities of the film. In addition, the color of the flash is nearly that of the sun, so color balance is achieved by eliminating the excess blue of the shade.

In theory this works well. In practice there is a basic problem. It is usually undesirable to make the photograph with the flash on the camera. If you do, you must keep the camera at the distance calculated for the flash, 10 feet in this example. That's a hindrance when you want to change the camera angle or distance. You will also need to keep the flash a bit higher than the camera in order to avoid throwing light up toward the face and creating objectionable shadows there.

The solution is to use an extension cord from camera to flash and have an assistant hold the flash at the correct distance. A good tripod can replace an assistant if necessary, but a person can be of help in other ways. Whichever way you choose, having the flash in a fixed position will allow you to be as flexible as you wish with camera location.

There are many automatic flash units available with different methods of operation. Check the owner's manual if you want to use your flash in the automatic mode. I recommend that you operate the flash in its manual mode using the technique I've described. It's simple and repeatable.

Of course, flash-fill techniques work well in color too. In the photo at left, the dark shadow creates too much contrast in the face. In addition, light illuminating the shadow is skylight, which is too blue. Using a flash to fill the shadow yield a much better photo, shown on the right.

Other Outdoor Considerations—

Weather is of great importance when working outdoors. This sounds like an unnecessary warning, but if you believe a bright sunny day is always required, you are probably missing some fine picture possibilities. The fact is, a slightly overcast day gives the scene a lovely softness and largely eliminates the lighting problems related to direct sun. If you are faced with a snow storm or rain, obviously I recommend you work inside, or if possible, plan for another day.

A place for the bride to dress may prove a problem in an outdoor location. Generally, she will not arrive at the site gowned, especially if she must travel by car. And the back seat won't do as a dressing room.

She must have privacy and the usual accessory items, such as mirror, chair, hooks for clothes hangers, and running water if possible. If the location is the backyard of her home, or yours, it should go smoothly. If you use a park or an outlying area, you must make arrangements beforehand. Find out what is available and what she needs. Then know what you plan to do and be sure the bride understands the plan.

Common Considerations—

Regardless of whether you are working indoors or outdoors, when the bride arrives, you should already be prepared. Indoors, you should have the basic lighting arrangement set, camera loaded and exposure and calculations made. Outdoors, you should have chosen the site, decided whether you will need a flash or reflector, determined the distance, and made approximate exposure calculations.

After the bride arrives and while she is dressing, busy yourself with a last-minute check of equipment. Check lights and all electrical cords. Make sure the cords are not in a position that can cause an accident when the bride moves about the set. If you are using electronic flash, be sure the camera shutter speed is set for the correct synchronization. In short, look at everything you will use and be sure you are comfortable, confident, and ready.

Remember that the newspaper will run the portrait in b&w, so that may be the film you choose. Many photographers realize the potential here for additional sales, and make the portrait on the same color negative film used for the wedding. If you choose to do the same, be aware of the time factor.

Unless you are processing the film yourself, it will have to be sent to a commercial lab, and processing and proofing may take somewhat longer than if you had used b&w. It is also sometimes difficult to find a lab that will make b&w prints from color negative film. If all these problems can be

Many parks and other public areas have buildings and stairs that you can use as compositional elements in outdoor portraits. Consider using them for a bit of variety. Photo by Steven A. Sint for Glenmar Photographers.

Opposite Page: Diffused sunlight on an overcast day is ideal for outdoor portraits. The lighting is very soft and pleasing and does not have any of the problems associated with direct sunlight. Photo by Steven A. Sint.

worked out, however, I recommend using color material because you can get some large print sales from this sitting.

If you have the time, you can make the exposures for publication on b&w film, then change to color negative film for additional poses. This way, you have given yourself the speed required for the newspaper photographs and the chance for the sale of color enlargements later.

POSING

The portrait you are making should show the bride with a radiant expression. Often, you will see a bride photographed with a pensive, dreamy look that often comes across as an expression of sorrow. If you feel you must take the artistic, moody views, leave them for the end of the sitting after you are sure you have a good choice of happy, smiling poses. She may very well pick one of the more serious views later as a gift for her parents, but I'll bet she uses a happy one for the newspaper.

Keep in mind that the newspaper is interested in a head-and-shoulders view, and anything more may be unacceptable. But this doesn't mean a mug shot. Your concern is to produce a salable, professional-looking portrait.

Remember that your posing concerns are twofold. First, you need to make a portrait for publication. Second, you want a selection of poses to be sold to the bride for her own use, or given later as gifts. The proofs for enlargements will be shown at the time wedding proofs are presented for the full order.

The dashed vertical lines represent the cropping the newspaper gives your 5x7 print. Be sure to make the full print and let the newspaper crop to fit their space.

Head and Shoulders—The bride's shoulders should be at a slight angle to the camera and her head should be turned toward the near shoulder. The head should be tipped up just a bit from the near shoulder with eyes toward the camera.

Any time the subject's eyes are directed toward the camera, a certain intimacy is established with those who view the photograph. The bride is taking a big step into marriage, and she wants the viewer to know she's proud and pleased with what's happening.

In the head-and-shoulders pose, hands, flowers and bibles are unimportant props because they won't be showing. Hands should be placed comfortably in the lap with elbows extended slightly to the sides so the shoulders have a smooth line.

Upper arms should slope gently away from the body rather than hanging straight down. Elbows tucked into the sides result in stooped shoulders and a pinched look to the upper body. Alternate the poses so the shoulders are first toward the right and then toward the left. Each change in shoulder position provides a different angle of the face.

This head-and-shoulder pose is good, but the photo shows too much of the subject. A better composition would be to crop out the area below the third button from the top. You can do this while printing the photo, but I recommend you crop in the camera's viewfinder when making the picture.

This is a good pose to try for a three-quarter view with or without a bouquet. If the bride has a hair style like this one, be sure you position the light so the face is not as shadowed as it is here.

With Bouquet—Several years ago it was popular for the bride to hold a bouquet near shoulder level while she gazed downward. Occasionally someone will still ask for such a pose, and if it happens to you, go along with the request. It is generally requested when the bride is trying to duplicate a photographic pose she has seen in her parent's wedding album. It is a pose that may sell at a later date.

If the bride wants a bouquet included in the head and shoulders view, by all means oblige her. Basically, the posing will be the same except that you will need some way to prop her elbows. The back of a chair will work nicely. The bride must sit so her shoulders are parallel to the chair back, still at an angle to the camera. She can do it by sitting side-saddle, if necessary.

Her elbows should be supported by the back of the chair and spread apart so the bouquet is positioned slightly below the shoulder line. The bouquet must be high enough to remain in the picture area when cropped for normal head and shoulder dimensions, yet low enough so that if the bride should tip her head forward she doesn't bury her nose in the flowers. She should *look* at the flowers, not smell them.

Try exposures with her head tipped forward slightly, eyes downward toward the bouquet, and then with head up, tipped to the side a bit, with eyes toward the camera. If you have a soft-focus filter, try it on some of the exposures. This pose lends itself well to slight diffusion. I don't recommend soft focus for the publication photograph because, if overdone, the reproduction appears mushy.

Three-Quarter Length—The three-quarter length pose can be made with the bride either standing or sitting. If she is sitting, she should be on a stool or some support that has no back, unless the back is very photogenic. A couch or chair back with severe lines or strong patterns will be very distracting.

Pose her head and shoulders as before. The hands are folded gracefully at waist level and elbows are slightly extended to the side. Crop the picture area just below the hands. This pose is ideal for hands holding a bouquet or bible, and it works equally well indoors or out.

For this three-quarter view, a soft-focus lens and white background were used to make a more esthetic portrait. This is fine for a print that will be framed and hung, but the contrast and separation between the subject and background are unsuitable for the newspaper portrait.

In this three-quarter pose with bouquet, the black background helps add contrast and separate detail. Both are necessary for good newspaper reproduction.

If you want to photograph a pose like this one, I suggest you do it inside to avoid damage to the wedding gown.

Full Length—These poses can also be done indoors or out, standing or seated. Unless you have access to a good uncluttered background, a standing pose will be difficult indoors. A long camera-to-subject distance is required as well. Usually, your best bet is to find a nice, clean outdoor location for full-length work.

If you use a seated pose outdoors, be careful where the bride sits. Gowns are expensive, delicate, and difficult to clean. A photographer friend of mine accidentally caused a gown to become soiled. Cleaning it took 10 days and $45. Because it was his fault, it was his cost.

We've discussed the three-quarter seated pose from the waist up. The seated full-length pose is the same. The legs should point in the same direction as the body, at a slight angle to the camera. If they are crossed, place the near leg over the far leg. The near-over-far rule applies whether the legs are crossed at the knee or ankle. Even if the gown is so long that it hides the ankle completely, the near-over-far rule provides a pleasing line to the material. It also puts the bride's weight on the far hip, so she doesn't appear to be falling toward the camera.

Full-length standing poses are just as simple. The body-and-shoulder line is at a slight angle to the camera. The hands are folded at waist level and the head tipped up slightly away from the near shoulder, facing the camera. The near foot should point toward the camera, with the far foot perpendicular to that line. The body weight should be on the far foot to give a pleasing line to the material.

Opposite Page: This full-length view was done in a studio so I could carefully control the lighting on both the subject and the background. Note the good modeling of facial tones due to careful placement of the lights.

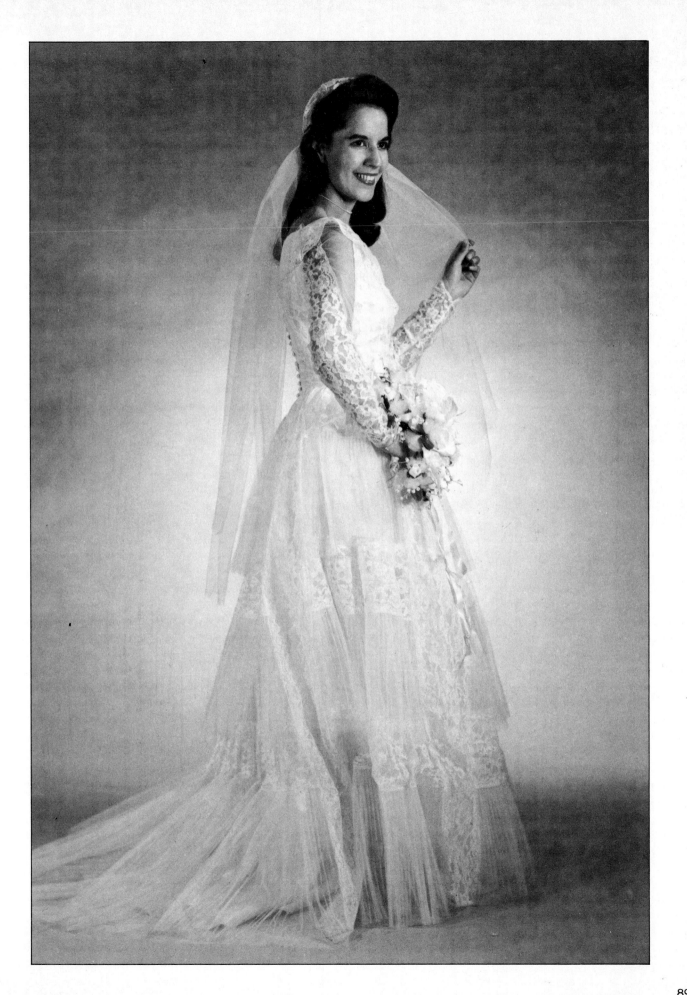

These full-length views were made at the church. They are acceptable, of course, but not as good as the photo on the preceding page. These kinds of portraits are more appropriate to the wedding album than for the newspaper or as a photo oil.

Problem Solving—If the bride has a long, narrow nose, avoid a high camera angle. The lower angle tends to shorten the nose and is much more flattering. Try to avoid profile views as much as possible. She will probably help you remember by resisting the pose that shows her to a disadvantage.

Eyeglasses are always a problem. The lighting must be arranged so that the lights don't reflect in lenses, and frames don't create shadows that make the eyes appear as black areas. Often, photographers combat the problem by either asking the subject to remove the glasses, or by providing similar frames without lenses in them.

If the bride always wears glasses, removing them will change her appearance and she will not look natural. Removing the lenses from the frames preserves the natural appearance of the face, but usually causes the eyes to squint in an unpleasant way. Another problem is that there are so many frame styles available that trying to keep a good selection on hand is virtually impossible. Unless you are an excellent photo retoucher, you must work with the lighting arrangement.

The simplest arrangement is a split-lighting pattern. Place the main light high and far enough to the subject's side so only half the face is lit. The fill light is placed at the camera position and just high enough to avoid reflection in the glasses. It sounds simple, but practice a bit before you expose film.

Be very careful with the split lighting so black areas don't appear at the inside corners of the eyes. Adjust the light so the eyeglass frames don't cast a shadow directly across the center of the eye. Keep the brightness ratio close to 3:1. If the fill light is much less than the main light, the shadows of the eyeglass frames will be objectionably dark.

When your subject sits with her body turned away from the camera and looks over the near shoulder toward you, she will naturally tip her head toward that shoulder. This uncomfortable pose is fine for glamour portraits, but the bride is interested in a different kind of photo.

General Considerations—Make enough exposures so the bride will have ample material for selection. Make the sitting a light, happy and brief happening. Don't create unnecessary delays that keep her in the gown too long. She may have had to make arrangements to pick up the gown from the shop before it was fully completed. If it is being held together with pins, this increases the risk of damage.

For the purpose of all the photographs discussed here, the veil should lay loosely over the shoulders and gently back over the head. You are making an after-the-fact photograph that will not be made public until after the ceremony. Veiled faces reproduce poorly in newsprint.

Everyone has seen the photograph of the bride with face veiled, perhaps in profile near a window, and it may be one of your bride's desires. Make that picture on the wedding day, just after the bride dresses and before she is escorted down the aisle. Although it's a poor publication photograph, it's perfect for the album.

Take all possible care in making the formal portrait. Because it will be delivered before the wedding date, it must be done well. If not, the bride will start having serious doubts about how you will handle the work on the big day. Really good work at this point will put her mind at ease and make the balance of your job much more pleasant.

A better pose for the portrait has the bride tipping her head away from the near shoulder.

AFTER THE PORTRAIT

This is the time to put together all the information you have gathered and to complete the details. You will find that the bride will be impressed that you have already spent some time at the wedding location. She will be quite pleased that you are concerned enough to have gone out of your way to prepare yourself for the event. Her confidence in you will be bolstered when you mention that you have met and talked with the person responsible for the details and planning of the ceremony.

The big day is drawing near, and this is the time the bride begins to doubt having covered all bases. Knowing that you are doing your part on her behalf will be reassuring to her. Keep in mind that this is not just another wedding to her, but possibly a once-in-a-lifetime step.

Make notes you will use later. Remember that you asked her to make a list of special photographs and the people she wants in them. Her list will probably include several of the standard photographs you would routinely take, as well as a number of pictures of particular individuals.

Unless the bride is a relative, or long-time friend, you will have no idea of what these people look like. Ask her to appoint one of the wedding party to be responsibile for pointing out these people to you. Assure her that you will make every effort to take each photograph she has listed and that the day will be fully documented.

Get all possible details at this meeting, because the next time you see her will be to deliver portrait proofs, and that visit will be brief.

You also might want to learn the names of the florist and caterer she will be using so you can contact them before the wedding day about making photographs of the floral and food arrangements. These people are always pleased to have their services pictured, and perhaps will be interested in purchasing several prints. You may want to present a print or two at no charge to receive recommendations for future weddings. If the florist and caterer are impressed with the quality of your work, they will be happy to recommend your services to other brides.

Set the date and time to deliver the portrait proofs and establish exactly when the prints must be completed for publication. If you are supplying prints for more than one local newspaper, each will want a different pose. After choosing the poses and making the 5x7 b&w prints, deliver them to the bride. She will get them to the newspapers along with any necessary information.

I recommend you don't show proofs of the color photos when you show b&w proofs for publication. Save them to show along with the wedding proofs. This way, the groom and assorted relatives get the opportunity to have a say in making the selection, and sales are invariably better. At this point your immediate concern is to select the pictures for publication. Showing the others may make the discussion unnecessarily lengthy and confusing.

As you finish this meeting, let the bride know that she should not hesitate to call you if any questions arise as the wedding day draws near. Assuring her of your cooperation will assure *you* of hers.

7
The Wedding and Reception

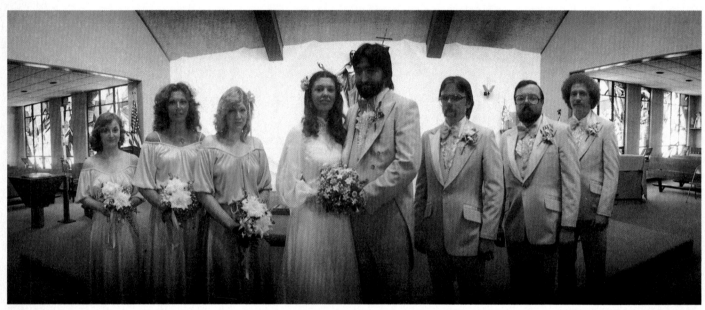

Photo by Kathy McLaughlin.

Today is the day! All is ready. Let's start with a list of standard photographs you want to be sure to get. This list, along with the special one the bride provided, will supply full coverage of the activities. See the next page.

If you have covered this list, plus any special scenes that occur or were requested, you've got it all. You'll never have to worry about shortchanging the couple on choices when you present the proofs. Now, let's go back through the list in a bit more detail.

THE WEDDING

Try to arrive well ahead of the appointed time so you can find a place to stash your equipment case. This way you will be prepared when the first picture opportunity presents itself. If the reception is to be held at another location, find a parking place that gives you a quick getaway. You don't want to arrive after the receiving line has started.

Check in at the bride's room to see if she has arrived. If she has, let her know you are there and ask that you be called just before she finishes the final touches of dressing. If she has not arrived, busy yourself with rechecking the areas you'll be photographing, making sure someone hasn't added a lot of furniture to the spot where you were going to stand, or that a drape hasn't been pulled closed, shutting out some nice natural light you counted on using.

If either of these things has happened, check with the church people and determine whether the furniture might be moved slightly or the drape opened for the particular photo you had in mind. If nothing can be done, mentally record the change in plan. Make one last equipment check.

Photocopy the form on the next page and use it as a checklist for photos you want to take during the ceremony. If you get all these pictures, you have done a good job.

94

STANDARD WEDDING PHOTOS

_____ 1 Bride putting on the finishing touches in the dressing room.

_____ 2 Mother adjusting bride's veil.

_____ 3 Placing garter on bride's leg.

_____ 4 Father placing penny in bride's shoe.

_____ 5 Bride helping attendants with final preparations.

_____ 6 Groom and best man checking wristwatch.

_____ 7 Groom adjusting best man's boutonniere.

_____ 8 Bride and father about to enter chapel.

_____ 9 Bride and father starting down the aisle.

_____ 10 Exchange of vows.

_____ 11 Bride and groom coming up the aisle.

_____ 12 Bride and groom kissing at church entrance.

_____ 13 Formal group portraits back at altar.

_____ a) Entire wedding party, with both sets of parents and all attendants.

_____ b) Bride and groom with attendants.

_____ c) Bride and groom with both sets of parents.

_____ d) Bride and groom and clergyman.

_____ e) Bride and groom with flower girl and ring bearer.

_____ f) Bride and groom alone.

_____ g) Bride alone.

_____ 14 Couple signing license in church office.

_____ 15 Maid or matron of honor and best man signing license.

_____ 16 Hands of bride and groom showing rings.

_____ 17 Wedding party entering cars for reception.

_____ 18 Receiving line at reception.

_____ 19 The cake before it is cut.

_____ 20 Wedding couple toasting each other.

_____ 21 Couple cutting cake and feeding each other.

_____ 22 First dance of bride and groom.

_____ 23 Bride dancing with father.

_____ 24 The head table.

_____ 25 The gift table.

_____ 26 Bride and groom with her parents.

_____ 27 Bride and groom with his parents.

_____ 28 Bride and groom with special guests.

_____ 29 Best man toasting wedding couple.

_____ 30 Bride throwing bouquet.

_____ 31 Picture of girl catching bouquet.

_____ 32 Groom removing and tossing bride's garter.

_____ 33 Picture of man who caught garter.

_____ 34 Bride and groom after changing to travel clothes.

_____ 35 Rice throwing.

_____ 36 Bride and groom leaving.

THE BRIDE'S ROOM

When the bride sends word that she is ready, you should be ready too. You will probably find yourself in a small, hot room, surrounded by a bride, four to six female attendants, one or two small children and a mother. Fortunately, most of the photographs here are made in close, so the crowded conditions are still workable enough.

The pictures usually include the mother or maid of honor adjusting the bridal veil. Then the maid of honor puts the garter on the bride's leg up to her knee. Sometimes the father puts a lucky penny in the bride's shoe and kisses her. Don't forget these.

If there are children as flower girls, ask them to kiss the bride as she leans toward them. If the bride's grandmother is present, a kiss for her from the bride will also make a nice photo.

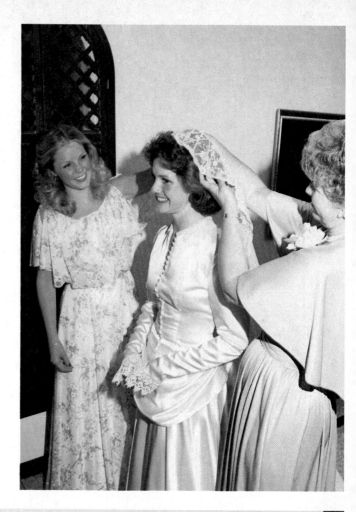

The bride's room is usually small and contains a lot of activity and emotion. There are plenty of picture opportunities here, so make many photos.

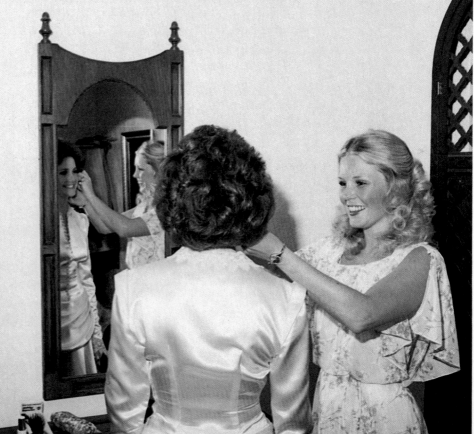

96

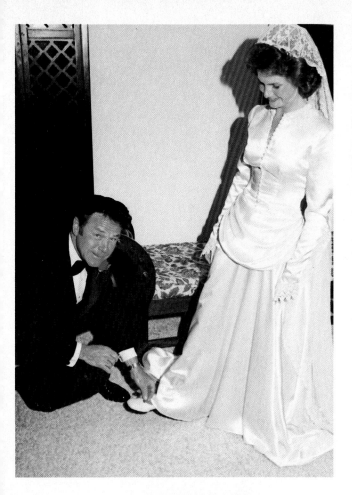

Each ceremony will have a different set of customs and practices. For example, some people use lucky pennies, as at left, some do a lot of kissing, and others collect in a group right before the ceremony, as in the photo below. It's your responsibility to find out exactly what the order of events will be. In the case of photos in the bride's room, you can ask the maid of honor what is going to happen next.

THE GROOM'S ROOM

It's not at all uncommon to have come this far in this story of love and romance and still not have met the groom. Now is the time. You've finished with the bride for the moment and must move on to the groom and best man. They will be in the groom's waiting room and a couple of pictures are called for here.

A photo of the groom and the best man looking at the best man's watch, followed by one of the groom straightening the best man's boutonniere will cover the situation. After all the time already spent with the bride, you may think that the groom is being slighted somewhat.

Granted, he is half the event, but he is the lesser half. This is truly the bride's day and if you haven't realized it after reading this far, you will as the activities continue.

There is one more photograph available here if there is a boy as ringbearer. Take one picture with the young man shaking hands with the groom.

Children can be a problem in a wedding party if they don't feel like part of the group. This picture will show the young man that you recognize him as an important part of the program. That could be of great help to you when you are ready to do the group work following the ceremony.

Pictures in the groom's room need not take very long. The men can straighten the flowers in each other's lapels, pretend to check the time, and shake hands in less than three minutes.

Before you leave the groom's waiting room, enlist the aid of the best man by asking him to help herd the wedding party around and back to a designated location for the group portraits immediately at the conclusion of the ceremony. This allows you time to set up your equipment while the wedding party is gathering.

Try to have him move everyone as quickly as possible so they are not standing around the front door when the guests come out. If the guests latch onto the bride and groom at that point, it will be extremely difficult to get them back for the portraits.

I recommend that you photograph the children of the wedding party at least once. It's a photo the bride will probably want, and it helps assure you of the children's cooperation later on. Photo by Diane Ensign-Caughey.

99

DOWN THE AISLE

During your earlier visit to the church, you learned the rules the church expects you to observe. Although these rules vary from one church to another, one that is almost universal is— *No flash exposures during the ceremony.* Typically, the ceremony begins as soon as the bride leaves her dressing room.

Go back to the bride's room to wait for the bride, father, and attendants to form the line prior to starting the journey down the aisle. As they line up, it is a good idea to make an exposure of each attendant as she moves toward the entrance. The final picture of this set will be of the bride and her father starting off, hand-on-arm, toward the waiting groom.

Now is a period when you may have a few minutes to compose yourself and take stock of things. If you are going to photograph the vows, you don't have any spare time, otherwise you wait until afterward. You are going to have to take at least three pictures in quick succession very shortly. Two will be of the bride and groom returning up the aisle, and one of the first kiss outside the door.

During this short but active period you will see several picture possibilities, so you'll want to be ready. I suggest that if you have fewer than six exposures remaining as the bride and her father start down the aisle, you should reload. It's not a big waste to throw away four or five blanks because there is no charge for not printing blank frames.

Everyone is starting to become nervous just before the ceremony begins. However, this is no time for *you* to. Get yourself ready for the important pictures that will follow shortly.

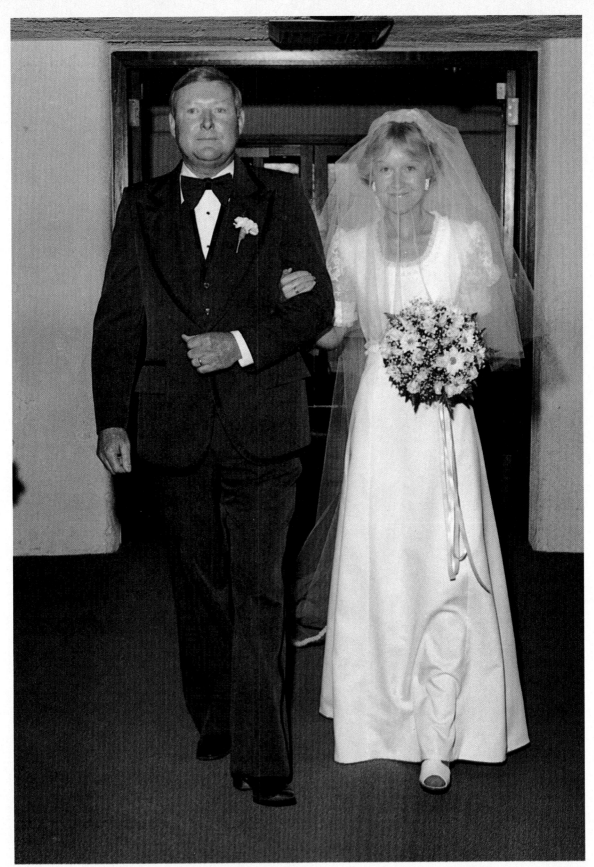

If you want to photograph the bride and her father walking down the aisle, be in the aisle before anyone enters it and have the camera prefocused as people walk toward you. This is probably the last time you can use flash until the wedding couple walks up the aisle at the end of the ceremony. Photo by Candid Wedding Photographers.

THE VOWS

There is a picture possibility coming up that is always very popular. This is the photo during the vows. This may require an exposure of up to one second, so some sort of camera brace is always necessary.

I have taken many of these by setting the camera on the floor in the aisle at the back of the chapel. Another good vantage point can be found along the railing of the choir loft at the rear of the chapel if the church has one. This view provides a high angle that includes not only the wedding party, but the guests as well.

One obvious problem is the noise of the camera. You must pick the correct moment for exposure so that the camera sounds won't draw undue attention to your efforts. If you are shooting a wedding with singing during the ceremony, that's the time to make the exposure.

Whether you decide to attempt this photograph or not, be sure you are not upstairs in the choir loft when the bride and groom begin their walk up the aisle. It's an easy picture to miss if you're not prepared.

There is very little action during the vows and many other parts of the ceremony. These are the times to make long-exposure photos. Bottom photo by Diane Ensign-Caughey.

102

Another important photo to make at this stage is the traditional kiss at the end of the vows. Usually, you get only one chance to photograph this kiss, so be in the right place at the right time to get the composition you want. For an outdoor wedding the big picture may be better than a close-up. In an indoor wedding, the close-up photo is usually best. All photos by Diane Ensign-Caughey.

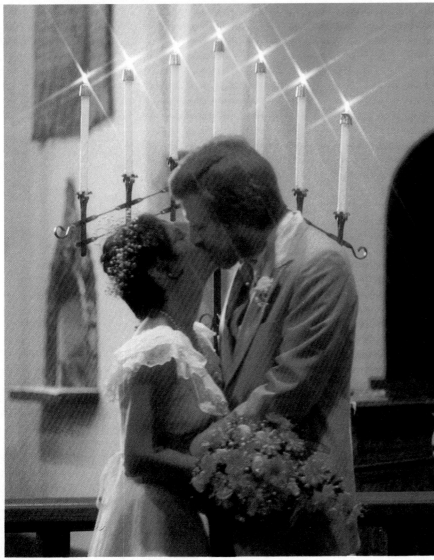

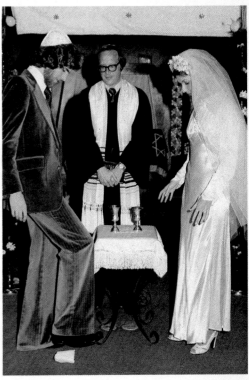

In a Jewish wedding, the traditional breaking of the glass is an important scene that comes after the vows.

UP THE AISLE

Try to make two exposures of the couple as they come toward you. For the first, the camera should be prefocused at a given point. Make the exposure when the couple reaches that point. Assuming there are no stairs, walk backward and try to keep the same distance to make another exposure as they near the end of the aisle. As soon as they have cleared the front door, ask them to kiss while you make another exposure.

As soon as the best man appears, remind him of your earlier request and get the wedding party started toward the location for the group pictures. Be sure the route taken is other than directly back from where they came. You want to avoid the guests.

As the party is forming for this short trip, stay alert for any picture possibilities that may pop up. It's an emotional moment and there is always a lot of hugging and kissing, so be ready to fire away. As soon as they have left under the leadership of the best man, obtain your equipment case from its hiding place and set up quickly for the portraits.

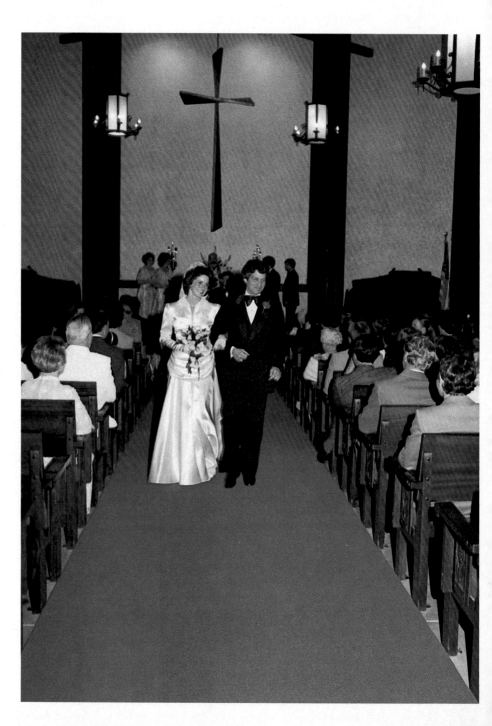

Photos of the couple walking up the aisle are not too difficult because you can use flash at this time. The only trick is being in position with the camera prefocused. Then walk backwards to keep the same distance and make an "insurance" shot. Depending on the length of the walk, you may be able to make three or four of these photos.

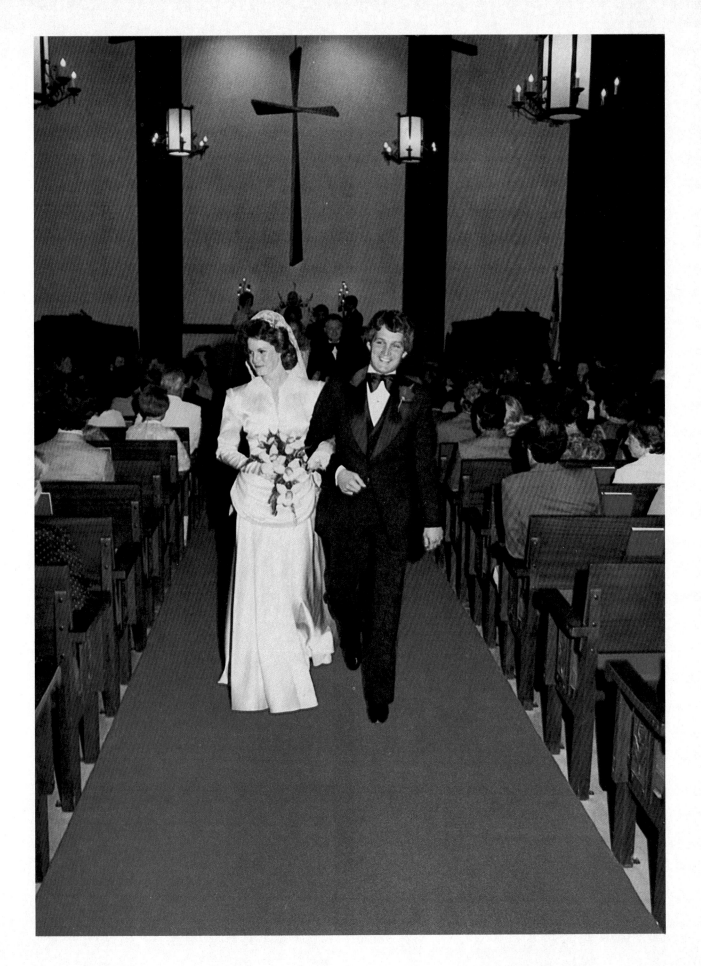

SIGNING THE LICENSE

At this point, one of two things will happen. Either the group will be gathered and milling around waiting for your instructions, or they won't be anywhere to be found. If they aren't there, don't panic. The most likely place to find them will be in the church office, preparing to sign the license. If that's the case, take the license-signing pictures now.

You want an exposure of the bride and groom signing the license. The signing by the best man and the maid of honor can be made as one photograph, with one party signing while the other stands at the side. The clergyman will appear in all of these pictures. It is a brief ceremony but an important one, so don't miss it.

The most important thing to remember for this brief procedure is that it *is* brief. If you are not ready or if you do not know where the office is, you can miss the shots.

106

Either one of these photos would be fine in the wedding album. It isn't necessary to include both, but I recommend that you shoot both. This way you can choose between the two and present the best one with the proofs.

107

THE GROUP PORTRAITS

If the wedding party did not stop by the office but came directly for the portraits, do the license-signing photos immediately following the group photos. Now is the time to become a bit authoritative. Don't be pushy, be firm. You've reached the point where everyone has started to relax and the party mood begins to prevail. The pictures you are now about to take are very important.

Groups can be difficult at best, so don't let them run away with you. Remember that there are guests outside waiting to congratulate the happy couple. Your work-

ing time is very short.

I strongly suggest that you mount the camera on a good tripod so that once the frame is composed, you can concentrate on getting the group's attention and elicit the expressions you want from them. It's wonderful to have an assistant any time during the wedding and reception, but never quite as much as when doing the group portraits. The second light and extra hands can help a great deal.

All of these people are awaiting your command, so line them up. I prefer to start with the largest group. This group includes the

bride and groom, both sets of parents and all attendants. By doing the large group first, you will be able to free a number of people to go outside and pacify the waiting guests.

The second picture should be with the bride and groom and both sets of parents. Don't let the attendants leave just yet because they will be in the third photograph. After the picture with the parents, thank them and explain that they're now free to greet the guests. I have found that because the parents are most apt to know more of the guests, it is preferable to excuse them first.

When photographing a wedding group this size, an assistant and second light are practically essential. Notice how evenly lit the scene is with no objectionable shadows obscuring important details. When making these group photos, be sure to make enough exposures to get one with all eyes open.

Even though I recommend that you shoot the above photo before the one below, you may want to do the opposite to avoid having to move the camera and flashes forward then back again.

Now comes the photograph of the bride and groom and their attendants, followed by the wedding couple with the flower girls and ring bearers, if any, and then with the clergyman. Because the groups have been getting smaller, you should move your tripod closer each time and refocus so the people fill the frame.

The final pictures are usually of the bride and groom alone, then the bride alone. There is always a possibility that you have instructions for special pictures, usually of visiting relatives, but I believe these can be better done at the reception than at this time.

You've now made seven photographs in as many minutes, or less, and things should be going well. If they are not going well, you didn't heed my warning about letting the group run away with you. If you weren't firm in your directions with the groups, you had better steel yourself because the reception is still ahead!

This photo is typical of those that are made on special request. Never hesitate to fulfill the wishes of the bride and groom when they ask you to photograph something or someone. Even though you have a preconceived plan to photograph certain people and events, you must be flexible enough to give your clients what they want.

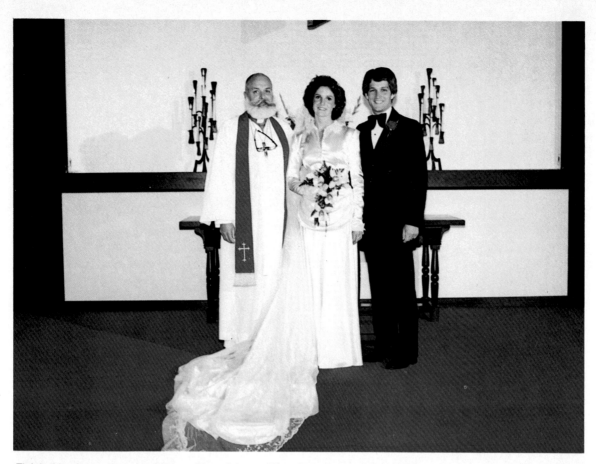

Finish this phase of group photos with a picture of the clergyman and the wedding couple and then a photo of the couple alone. A photo of the bride alone is always worth trying at this point. In fact, you may be able to use the photo as a speculative enlargement, as described earlier.

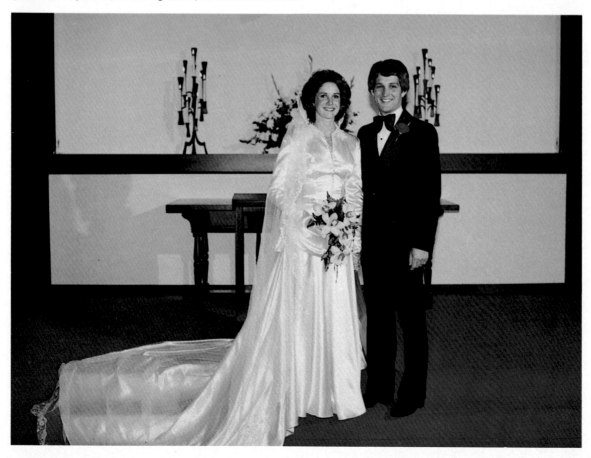

THE RECEPTION

Basically, the reception is a party. To get all of the photographs you will need, you must make suggestions or know the order of things. If you miss the standard pictures here, you are the one who will be blamed later, even if it's not your fault. By all means, ask from time to time when the bride expects to cut the cake, throw the bouquet, or leave the scene. Receptions differ greatly in the order of events; however, most include the following events.

When you photograph the receiving line, include the faces of both guests and hosts in the photo.

THE RECEIVING LINE

This is a line made up of either the entire wedding party or only the bride and groom and their parents. The guests file past and congratulate everyone involved. The congratulations are usually accompanied by much hugging and kissing, so this is a great place to get pictures of the bride and groom with close relatives and friends. Don't get overzealous and make a large number of exposures, however, because most will look alike and very few print orders will result. Also, when photographing two lines of people, it is difficult to include everyone's face. I recommend you photograph from the side of the line and make only a few exposures.

Generally, photographs of people eating are necessary only if the bride requests photos of those people. However, be sure to photograph the bride and groom at their table.

THE DINNER

If food is served, it will follow the completion of the receiving line. Guests are supposed to wait until the wedding couple is served or goes through the buffet line. A picture of the couple here is in order.

After guests are seated and served, take photographs of groups eating, but only those you feel are of the greatest importance to the bride and groom. Again, only photographs of those people closest to the couple will probably be ordered. Be sure to include the head table, because it is the one photograph ordered most often.

Traditionally, the bride and groom are served first, but sometimes a hungry child gets at the food first.

113

When you photograph a fast-breaking event such as the cake cutting, you should make plenty of exposures to catch the peak action and expressions on film.

THE WEDDING COUPLE

You'll recall I've already mentioned the growing popularity of a photograph of the couple for newspaper release. You'll also remember that I tried to steer you away from that, in favor of a picture of the bride alone. Despite all of your good intentions and mine, you may have been asked to make a couple portrait after the wedding. If so, now is the time to look for the proper setting.

If you must make this photograph, try your best to do it as artfully as possible. This means proper location and lighting. It also means the proper time, which is

whenever you can diplomatically get the couple to a quiet, photogenic spot alone. Don't drag the couple away from their guests. They won't appreciate that.

However, at the right moment they will appreciate the chance to take a break for a few minutes away from the happy throng. You should already have a secluded place picked out and know exactly what you are to do. Stay alert, be prepared and make your move when you feel the time is right.

THE CAKE CUTTING

This activity usually follows the receiving line or the dinner, if

there is one. This is an important set of pictures and a fun time for everyone. Take a picture of the cake alone before it is cut. This photo is often ordered and placed as the first entry in the album. I customarily make the cake picture as a gift, included in the album. It is always appreciated and many times it is also bought by the caterer.

The bride and groom should stand on the opposite side of the table from you. You must be at a slight angle so the cake does not hide their hands. The bride holds the knife with the groom's hand covering hers.

After the bride has removed a piece of cake, it's time for the squashing scene. This is where the bride feeds a bit of cake to the groom, usually as carelessly as possible.

After the groom cleans his face, it's his turn to feed the cake to the bride. It's always a mistake for the bride to be too messy during her turn at feeding, because she gets back what she dished out, several times over. Don't limit yourself to only one or two exposures during this mess because the last of several may be the best of all.

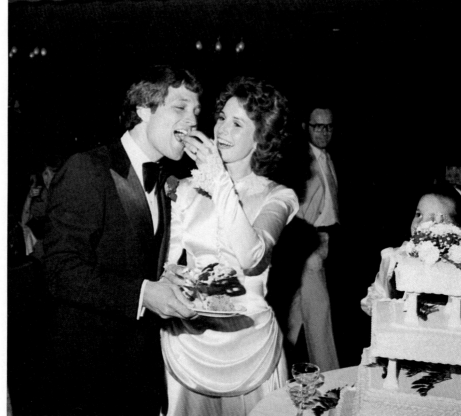

THE TOAST

For this photograph, the bride and groom entwine their arms and take a sip from their champagne glasses. It's an awkward scene at best, especially if the couple has a great height difference. Don't rely on one exposure, take several. As ungraceful as it usually is, this picture is nearly always expected and ordered from the proofs, so you want to get the best possible photo.

Here are three different ways to photograph the bride and groom toasting each other. If you are quick, you may be able to catch each of these poses and choose the best from the bunch. Bottom photo and one at right by Diane Ensign-Caughey.

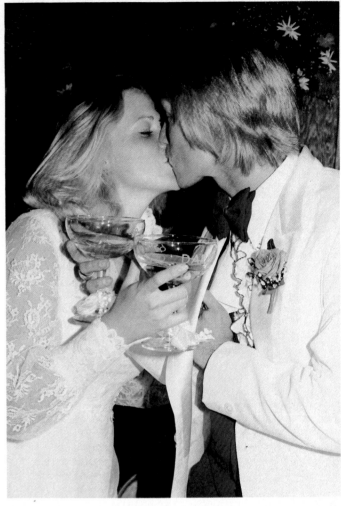

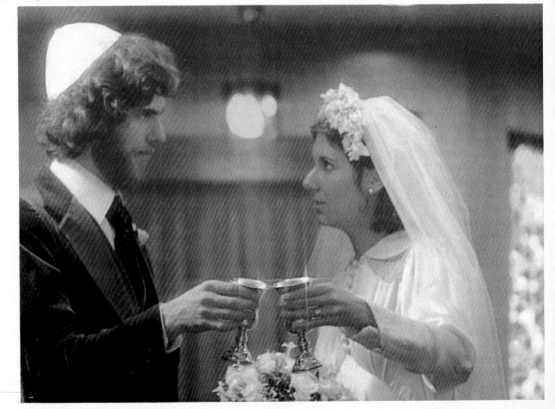

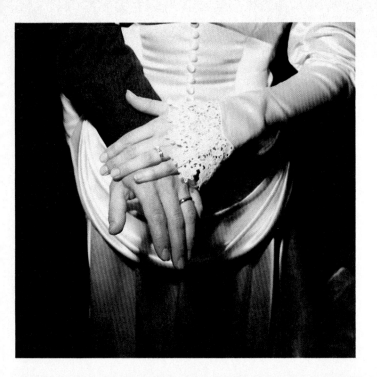

This is one way to photograph the wedding rings; however, it's not very colorful because of the black and white background.

THE RINGS

Usually, this picture is for double-ring weddings. While you have the couple within your reach, it's a good time to do it. The bride holds her left hand out with fingers extended, and the groom places his left hand over hers in such a way that both of their rings are shown. The skirt of the bridal gown is a satisfactory background, but the bouquet is much nicer. The hands are photographed close up, so they almost fill the entire frame. Fill the rest of the frame with the bouquet colors to accent the rings.

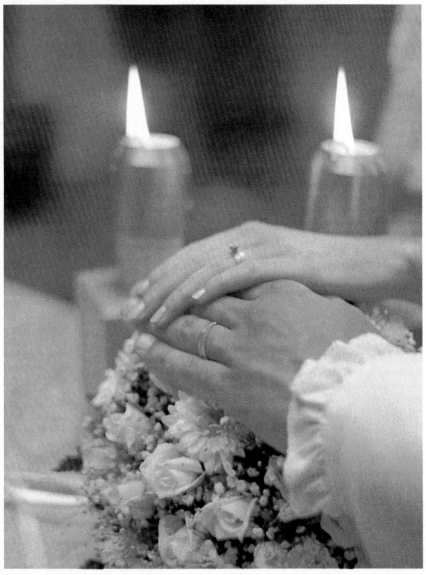

A much nicer background is a bouquet of flowers. This photo was lit by candlelight and tungsten lights.

MINGLE TIME

If you have been able to hold the couple's attention since the cake cutting, let them mingle with the guests for a while. It's important to keep them headed in the direction of the pictures you need, but don't hold them for more than two or three scenes at a time. They want to relax and enjoy themselves at their party, so don't let them feel that you are trying to dominate their time. There are still several photographs to take, but the end is near, so press on.

Scenes of the wedding couple mingling with guests should be relaxed and informal. Don't be too intrusive or demanding of certain poses. You will rarely need to do much more than follow them around and take pictures.

THE DANCE

If there is music, the couple will be expected to lead the dancing. It will be their first dance together as husband and wife, so the floor will be theirs. Because they will be the only ones on the dance floor, this photograph is simple enough to get.

Don't hesitate, though, because the guests will join in quickly. You can also photograph the bride dancing with her father and the groom dancing with his mother. Very few, if any, other dance pictures will be necessary.

These three basic dance pictures are the only required ones. If you are unsure of whom else you should photograph, ask the bride. Photos by Diane Ensign-Caughey.

After the bride and groom are finished with the cake, you can always ask other people to take their turn with the cake.

MORE GROUPS

While the guests are dancing and enjoying the music, this is a good time to do the special group photos that may be on the bride's list. There could be the wedding couple with her parents, then with his, as well as grandparents, close relatives and friends.

Once you set the couple in a good spot for small groups, they will let you know what they want. Check over the bride's list and remind her of the people she wanted included. This may be the last good chance you have to get them all together.

If you didn't get a chance to photograph the bride and groom with the clergyman at the wedding site, you may be able to do it at the reception. Photo by Diane Ensign-Caughey.

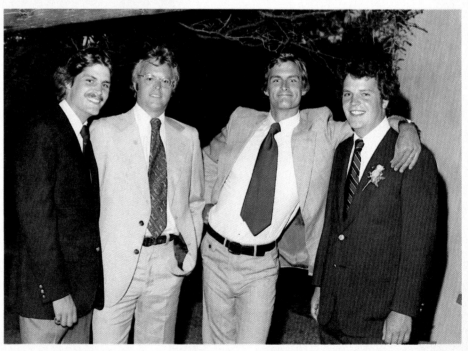

To make a group photo like this one, you may have to rely on someone else to recognize the individuals and get them together. Be sure there is someone in the wedding party who can help you do this. Photo by Diane Ensign-Caughey.

BOUQUET THROWING

Somewhere near this point a few of the guests will begin to leave. Remind the bride that she has yet to throw the bouquet and that she will want as many of the single ladies to participate as possible.

This picture can be taken from just about any angle you want, as long as both the bride and the single ladies are in the scene. I prefer to stand on a chair and take it from a fairly high viewpoint. In this manner, you can include the throw, the bouquet in the air and the upturned faces of the group of girls.

Don't let the bride throw before you are ready. Compose, focus and give her the signal. It all happens rapidly, so be sure you're ready. Also be sure of getting a picture of the bride and the winning catcher. The winner may place a print order for that photo.

Because it freezes action effectively, electronic flash is essential for the bouquet-throwing scene. Try to capture peak action.

A photo of the lucky catcher is one you shouldn't miss.

GARTER THROWING

Now ask the groom to gather the single men for the garter toss. Take a picture of the groom removing the garter from the bride's leg from a fairly low angle, but compose the frame to show the bride's full length.

Be careful with this scene—many times a fun-loving groom will nearly undress his bride while getting to the garter. It seems great fun at the time, but when the proofs are delivered, his zest may not be strong enough to order this print for the album. Wait until he has the garter between knee and ankle to make the exposure.

As for the toss, I handle it the same way as I did the throwing of the bouquet—high angle, garter in flight, composed with both groom and single men in the frame.

Photographing the garter ceremony is fairly easy. Everyone is having a good time at this stage of the reception, so you'll always be able to capture exuberant expressions and action. Photos by Diane Ensign-Caughey.

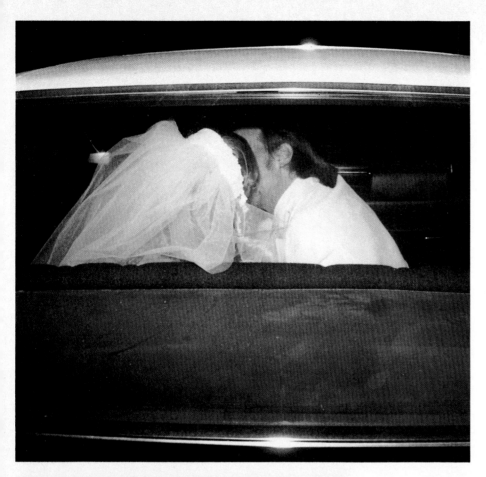

GOING AWAY

If the wedding couple is leaving for a honeymoon trip following the reception, you still have a few pictures to take. These include:

The couple dressed in travel clothes.
The couple running to the decorated car.
The couple in the car, waving goodbye.

Photos by Diane Ensign-Caughey.

THE NEXT STEP

That's it. You're finished for the day except to drop off the exposed film at the photo lab. If you've done all I've gone over, you have done a complete job.

You've probably taken pictures I did not mention but were requested by parents, guests, or attendants. Variations from the events I described create different photos. Unless these pictures were taken at the request of the bride, be sure and get the name and address of subjects so these people can be contacted and shown proofs later. The wedding couple won't order prints of these, and unless they are seen by those photographed, the negatives will gather dust in your storage files.

I've mentioned quite a few photos that are usually preferred by typical customers. Some want less coverage, some more. Maybe you looked through the list and felt it was a compilation of the same old corny stuff. After all, the bride did tell you she liked your work because it was different, didn't she?

Here are three typical examples of extra photos that may interest the bride, although they are not on the list on page 95. It's your responsibility to recognize and exploit as many picture possibilities as you can. Above photo by Diane Ensign-Caughey.

124

Perhaps the list does appear old fashioned. Just because this is my book, should I be so bold as to presume to tell you what the bride wants? You bet I will!

I admit that you know the bride and I don't. After all, she did come to you. However, I'm still recommending that you try to get most of what is on that list.

I'm sure you'll find many photographic situations that I haven't noted, but remember my intent is to tell you what you should know before you begin. Use your imagination. Be creative, but not at the expense of passing by photographs someone really wants.

Take many pictures when you feel it's right. Don't take those you feel would be embarrassing later. You might want to do another wedding someday and that opportunity comes from doing well each time you do a job.

MORE ABOUT PROFESSIONAL ETIQUETTE

If the bar is set up, smile as you pass by. Nothing will draw attention to you faster than a few stiff drinks. If you can't see the scene to photograph it, you won't like it when you view the proofs and neither will anyone else.

Possibly the wedding couple are old and dear friends and you're doing this job out of friendship. It may be as big a celebration to you as it is to them, and you want to enjoy it as they do. If so, decide at the first meeting. Explain that you appreciate their confidence in you and that you are flattered at being asked for your services, but you must decline.

Tell them that you would like to savor the fun and that it would be better if they selected another photographer. I promise you that everyone will be happier. Falling drunk into the punchbowl is hard to overlook, even for old friends.

8 Other Ceremonies

There are many ceremonies other than weddings that deserve photographic documentation. There are religious ceremonies, such as bar mitzvahs and christenings, and civil ceremonies such as ribbon-cuttings and the swearing-in of newly elected officials. I know photographers who have even been requested to document divorces and funerals. In fact, funeral albums are not uncommon. The assignment may not intrigue you much, but you may be asked to do one someday.

Someday you may be asked to make a picture during a religious ceremony like this one. Even if you've never done it before, the job can be easy and enjoyable when you go into it prepared. Photo by Diane Ensign-Caughey.

Two key photos of a christening ceremony are shown here. At left is a photo of the child and parents together. At right is the pouring of the water. For the second photo, the photographer should have moved in much closer and given the child a bigger share of the picture frame. Photos by Thomas Taylor.

RELIGIOUS CEREMONIES

Any religious ceremony has a specific order of events and a certain set of rules. Religious organizations have determined appropriate customs and behavior for occasions from birth to death.

It is your responsibility to be aware of these customs before you photograph such ceremonies. Dropping a camera bag can be overlooked as an unfortunate accident, but using a flash at the wrong time is not an accident. It is an inconsiderate act and will be viewed as such.

As I discussed in the wedding section of this book, always take time beforehand to visit the site of the religious ceremony after you have discussed what the client wants. Make an appointment to spend a short time with the person in charge. That person might be a priest, minister, rabbi or someone who arranges the event.

The photos above and at right are from an album of *bar mitzvah* pictures. No photos could be made during this particular ceremony, so the photographer arranged various posed shots *after* the ceremony. If you have to create posed photos, try combinations of parents, child, rabbi, and backgrounds in both horizontal and vertical format. Because you don't have the different phases of the ceremony to help create different images, you have to add some visual variety of your own. Photos courtesy of Barbara Feinstein.

The photo below is of a *bat mitzvah*. It *was* made during the ceremony, which gives it a more natural effect. Photo by Howard Skolnik.

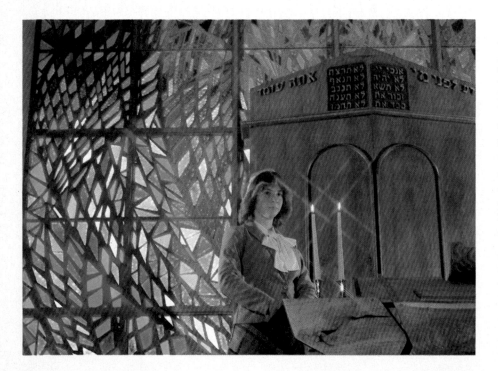

In any case, learn the rules and the order of events. When may a picture be taken and when not? May flash be used? If flash is permitted, where and when? Are there specific areas you may not enter? Where can you store extra equipment?

Ask about everything that crosses your mind. This is especially important if you are working in an unfamiliar place or with a faith other than your own. The person in charge will understand that you are sincere in your desire to abide by the rules and will not consider your questions to be irrelevant or stupid. You're both interested in the same thing—a well-run and well-documented ceremony.

CIVIL CEREMONIES

The civil ceremony, such as swearing-in new officials, cutting ribbons, opening the new city dump, or erecting a corner mail box, can be a bit different than a religious ceremony.

It may be much less formal, but also may last a great deal longer and be less predictable. Often, no more than two or three photographs are necessary, such as when a small group watches a chief executive cut a ribbon to open a new department store. On the other hand, you may have to follow the group around on a tour of the shopping mall after the ribbon is cut.

The pictures required will be determined by the type and importance of the event and the needs of the person who contacts you. Once again, someone is in charge, and you will take directions from that person.

A ribbon cutting is a typical civil ceremony often photographed. Your best vantage point for photographing such an event is opposite the ribbon and cutters, which is in the area to be officially opened.

Make plenty of exposures because there is only one ribbon to cut and it takes very little time to cut it, especially when four people handle one pair of scissors. Photo by Gary G. Morris, courtesy of the City of Tucson Office of Community Relations.

The new mayor may want to be recorded as he or she takes the oath of office and then may require continuing coverage at a banquet later. Be sure you get the information ahead of time from the person in charge. Most civil ceremonies present fewer rules to observe than religious ceremonies, and the rules are mostly those of common sense.

A *christening* is a civil ceremony in which champagne is used. The Andrew J. Russell photo on the opposite page shows the meeting between Eastern and Western railroads at Promontory, Utah in 1869. You can see wine bottles and champagne being exchanged near the center of the photo. The wine bottles were used to christen the locomotives; no doubt the champagne was drunk by some of the folks in the photo. Photo courtesy of Union Pacific Railroad Museum Collection.

Modern christenings, still use champagne, but in a more destructive fashion. In the bottom photo on the opposite page, the freighter *M/V Fred R. White, Jr.* is officially graced with an exploding bottle of the bubbly. Good timing by the photographer helped him capture peak action and the surprise of the participants. Photo courtesy of the Bay Shipbuilding Corp.

When not cutting ribbons, city officials can often be found at ground-breaking ceremonies. There are a couple good ways to handle these scenes. You can do what photographer Gary G. Morris did for the photo on the cover of this book, a posed group portrait. Or, you can try what he did for this photo, an action shot of the first dirt being turned. Unlike a ribbon-cutting ceremony, you are able to reshoot this kind of photo if necessary. Photo courtesy of the City of Tucson Office of Community Relations.

PRESENTATIONS, AWARDS & REWARDS

Of the many aspects of group photography, both the easiest and most difficult is photographing awards, rewards and presentations. It's easiest because it nearly always involves little more than standing the participants in place and firing away. It's the most difficult because it makes for boring pictures. Never more apt is the old saying "You've seen one, you've seen them all."

It shouldn't be that way, of course, but you have very little choice due to a fact of human nature—everyone wants to see his or her face in print, especially if he or she has done a good thing. For example, let's say a civic organization has raised money to provide a specialized piece of equipment for a charitable group. Let's also say you have been asked to document the presentation of the check.

Presentations—There are two ways to deal with this situation.

The first is to stand the donor representative, usually the club president, and the receiving representative, usually the charity's executive officer, in front of a relatively pleasing background and make exposures as the check is passed. This is known as the *give-and-shake*, *grin-and-grab*, or *grip-and-grin* picture. The beauty of this arrangement is that both participants are equally prominent. That's the boring part as well because nothing is happening.

This is a typical *grip-and-grin* photo. Everyone is grinning and two are gripping, so the photo is successful. Making this kind of photo is all that is expected of you, but if you have a chance to be more creative, be so! Photo by George Kew.

To make a less formal and posed presentation photo, try photographing the participants during a relaxed bit of conversation either immediately before or after the official presentation. Photo by Jon Alquist courtesy of the University of Arizona Alumni Office.

The other way to handle the job is by far the better of the two. Since the purpose of the donation is to purchase specialized equipment, why not show the equipment in use? The donor and recipient can certainly be a part of the scene, but the emphasis is on the item made possible by the donation. It makes a much more interesting and meaningful picture, especially if the equipment is of an exotic nature, complete with lights and lots of chrome.

Unfortunately, your chance to make such a photograph is very slim. Human nature dictates the former arrangement—grip and grin. People want to be seen as either donor or receiver. Certainly that's not bad because each donor needs a receiver and vice versa. However, always consider an alternative to the grin and grab. You may get the chance to do it.

Or, consider photographing the recipient alone with whatever was presented. This kind of photo will usually have more impact than a grip-and-grin photo if only because it is not the standard way of doing it. Photo by George Kew.

Awards—What I have just described is a presentation. To me, a presentation takes place when a person or a group presents something of value to another person or group. An award is usually given to an individual, although it could be given to a group to honor some achievement. An award is basically a prize for reaching a goal.

Award ceremonies are a great deal like presentations in that usually one person is required to stand up and hand something to someone else. The object handed can be anything from a trophy to a fur coat. The reason for the award and the nature of the award itself will dictate the photographic requirements. Awards should be happy affairs and the participants should appear as pleased as possible. Stern, solemn facial expressions tend to make those who later view the picture wonder why the award winner went to the trouble to reach the goal.

Award giving usually takes on a more informal feeling than that of the presentation. It should be a happy, relaxed affair and the

Good ways to photograph an award ceremony are not much different than those of presentations. A sequence of pictures from an award ceremony is shown here. Notice that each photo, if viewed separately, can fulfill the purpose more than adequately. Therefore, I suggest you always photograph different phases of the ceremony to give your client the best possible photo for his needs. Don't make just one exposure. Photos by Gary G. Morris courtesy of the City of Tucson Office of Community Relations.

photographs should recreate that atmosphere in later years.

You have little, if any, control over location, which of course includes background. If the ceremony is small, involving only a very few people, you may be able to get the group to the location you choose. If the affair is larger, such as a graduating class, the official handing out the awards will pick the place.

In the latter case, you will, as usual, arrive well ahead of time, find the best location for camera and lights and perform the standard preparations: select proper lens, set lights, determine exposure and review the order of events. I suggest you remain as versatile as possible when photographing award ceremonies. This may well mean you must forego attaching the camera to a tripod. People receiving awards are easily spurred to extemporaneous acts not necessarily taking place within the area framed by a tripod-mounted camera. Be on the lookout for that spur-of-the-moment act taking place a bit away from stage center. If you are ready when it happens, you can get some very memorable photographs.

Rewards—A reward is more emotional or personal than a presentation or award. Rewards are more in the order of a kiss or a touch. They are difficult to document because they tend to be spontaneous. In that regard, they are the most enjoyable of the presentation-award-reward group.

A reward often comes in reaction to a favor or kindness offered. In my hospital work, I often witness rewards given purely because someone came by to visit. Such rewards take the form of a touch of the hand or a kiss on the nose. Being around when such a picture opportunity presents itself has been of considerable reward to me as well.

Possibly you have a slightly different definition of the presentation, award and reward than I've outlined. I believe you'll find I've put forth a simple description of the basics of each. The presentation is relatively formal and straightforward. You are better off bending to the will of the participants. A standard documentary photograph is the object. Don't push the people involved into more than they want or need.

The award offers a chance to work a bit more informally while keeping alert for that extra something brought on by the joy of the moment. The basis, however, is still documentary.

Reward photographs are best taken as they present themselves. They seldom work when staged. Consequently, such things as background and lighting may at times be less than desirable. These technical deficiencies are easily overlooked, however, when the feeling of the moment comes through. Rewards can be wonderful. Look for them.

In my opinion, reward photographs are of an emotional nature. Perhaps it is the moment one hand touches another or when a kiss is planted on a mouse's nose.

9
Photographing Groups

A group is an interesting organism. It is two or more of anything that functions as a single unit. Even though a group is made of individuals, each with his or her own mind, the group is of a single mind. With unruly individuals, each can be thumped on top of the head to induce some semblance of order, but you can't thump a group's head.

Some groups are best approached by darting secretively from bush to bush until you're close enough to take its picture. Others are peaceful and can be approached directly. All groups, however, must be controlled and directed properly for good photographic results. You must show no fear or the group will sense it. A group can be frightening to photograph, especially in one of these circumstances:

You don't know any of the individuals.

Each person is an authoritative, executive type.

Each person is much older or younger than you.

Each person is bigger than you.

Each person is smarter than you.

Each person is a photographer!

Photographing some of the most powerful military men in the world can certainly be an intimidating experience. Whether you photograph the Joint Chiefs of Staff or a Little League baseball team, you *must* be confident, prepared, and in control; otherwise, you won't get the picture you want. Photo by Bob Ward courtesy of the Department of Defense.

In the wedding chapters, you'll remember I stressed gentleness and thoughtfulness on your part. Even for the formal group portraits I said be firm, not overbearing. This section of the book doesn't deal with the type of group you'll see at a wedding. Rather, I'll talk about the groups that form because of a common interest—business, educational, religious, fraternal or social. I'll also discuss some situations in which you may be called upon to record a meeting of a group featuring a speaker or performance.

Not all groups want to be photographed, of course, but nearly all wish such a record at one time or another—many on a regular basis, a few on a one-time arrangement. A group that elects officers periodically is a prime candidate for regular photographic sessions. So is the group whose membership changes because of age limits or other eligibility factors.

In this chapter I'll discuss some basic considerations of all group photography. The chapters that follow deal with groups of specific size and the best ways to deal with them.

EQUIPMENT AND LIGHTING

A 35mm SLR camera and a single flash unit can certainly prove adequate when working with small and very small groups. However, some small groups and all large groups should not be photographed with 35mm film. Large groups seem to want large prints so everyone is recognizable. Unless your 35mm technique is flawless, you may be disappointed with the results.

Camera—As a rule of thumb, I use 35mm equipment for a very small group and increase camera size as group size increases. Therefore, I choose a medium-format camera for work with a small group and nothing less than 4x5 for a large group.

If you are using 35mm equipment exclusively, *do not* attempt large groups or even small groups if you have not planned ahead thoroughly. I know this may limit you, but I mean to do just that. I'm writing this book to guide you along and keep you from getting in over your head. Attempting to photograph a big group with small equipment *is* over your head. Don't do it!

A 35mm SLR was used to make this publicity photo of a large group. The print suffers from lack of detail—individual members of the group are unrecognizable. This may be OK if individuals aren't supposed to be recognizable, but for best results either way, I recommend you use medium- or large-format equipment to photograph a group this size. Photo courtesy of the Tucson Symphony.

Do not buy, borrow or rent a large-format camera for a group picture unless you know you have the necessary time to experiment and learn about the camera before you take the picture.

Lenses—When choosing a lens for a group photograph, remember that you want as large an image as possible, and you want to be close enough so you can communicate to the group without having to send your directions by mail. Long focal length lenses are out. Your camera's standard lens is most satisfactory for very small and most small groups.

For some groups in the "small" category, however, a wide-angle lens will help. A 35mm or 28mm lens works well for 35mm cameras, and it allows you to choose a convenient camera distance. A lens with a focal length shorter than 28mm increases the possibility of distortion.

Lens choice comes from experience or, lacking that, taking the necessary time to plan ahead. If you are not sure what you'll need, arrive well ahead of time and check the area where the photograph will be taken, viewing the scene through the available lenses. Check to see what's included in the foreground with each lens.

Having lenses other than the standard focal lengths allows you greater freedom in posing the group. A longer lens restricts composition to a fairly tight arrangement for the largest possible image: The larger the image, the more recognizable each part of the group. Remember, if they can't see themselves in the print, they won't buy it!

Tripod—Always use a tripod. You have to pose the group, keep its attention, focus the camera lens, keep the composition steady, watch for outside influences and maintain a line of communication. That's a tough task when trying to handhold the camera and work through the viewfinder. The best line of communication is eye-to-eye. You can see the eyes through the viewfinder, but when you're behind the camera, the other eyes can't see yours. When you move away from the viewfinder, you allow the group to respond to you rather than to the lens.

When you use a tripod, controlling the group is easy if you follow this procedure:

1 Arrange the group in the preselected location.
2 Set the group up in the desired composition.

What are all of these people looking at? The photographer, of course, who is *not* standing next to the camera. In my opinion, this lack of eye contact between the group and the viewer of the photograph makes this picture much less acceptable than it could have been. Always try to maintain eye contact between you and the group while you are at the camera.

3 Put the camera on a tripod and position it so you can see the desired composition.

4 Make the exposure settings and focus the camera lens.

5 Stand eye-to-eye with the group.

6 At the moment you have the group's total attention and the expressions you want, make the exposure.

Metering—Whether you are using a hand-held exposure meter or a meter built into your camera, make a reading as the group is getting into place and set the camera's exposure controls accordingly. If you are working with daylight, the necessary exposure is not apt to change before you're ready to take the picture. If you are using artificial light over which you have no control, you will probably make slight lighting adjustments after the group is positioned. Make another reading just before you make the exposure. However, the reading you made beforehand will be close and the final adjustment will probably be small. In either case, the exposure is just as important to the success of the photograph as focus, composition or any other single element in the total procedure.

Outdoor Lighting—The simplest approach is to make a rule that you will photograph groups only on clear, sunny days between the hours of 10 and 2. When a group forms, however, it is usually for a reason other than to have its picture made. This means that lighting can be a real problem at times.

Keep in mind that wedding photographs and group photographs may be quite different situations. A couple will go ahead with a wedding whether you are there or not, but a group won't pose for a picture unless you are there to take it. The group is not standing about as a favor to you; rather, you are there to fulfill its need. That puts you in a position of some command. If a group has formed for its photograph and the day is nice, you should strongly suggest the work be done in sunlight. Because you are there as a favor to the group whether you're being paid or not, there is no reason to make things difficult for yourself.

Daylight, of course, has great advantages when you can use it. You can have the benefits of fast shutter speeds and small lens apertures to increase the chance of sharp pictures. This is very important for producing high-quality group photographs.

139

The photo at left was made outdoors in bright midday sun. As described earlier in the book, this kind of sun creates unpleasant facial shadow. To solve this problem, photographer Gary G. Morris used flash fill to lighten the shadows.

For the indoor group shown below, he used flash again. A large flash bounced into an umbrella gave sufficient coverage of the indoor area. You can get similar results using the two-flash method described earlier in this book. Both photos courtesy of the City of Tucson Office of Community Relations.

The outdoor location and the time of day you choose will dictate the angle of the light. If you can, arrange the group so the light is from the side rather than directly from the front. Strong front lighting can cause squinting eyes and wrinkled brows. Side lighting helps eliminate the frown. If the daylight is extremely bright, make sure that shadows on the faces aren't too dark due to side lighting. You may want to go back a few chapters and refresh your memory concerning flash or reflector fill light for backlit situations.

If the appointed day is overcast with a solid cloud cover, you are in luck. Cloudy days provide even, almost shadowless, lighting. Regardless of the group's arrangement, eyes won't squint, nor faces frown. Dark shadows caused by strong directional light cease to be

a problem. Cloudy days can prove the most flattering to the group and the easiest for you.

Indoor Lighting—When photographing a group indoors, it's extremely important to check ahead of time to see if you must use available light or create some of your own. If at all possible, look the location over well before the group will assemble. Don't take someone else's word concerning what you can expect to find. One person will tell you to bring lots of lights just because you will be indoors. Another will say you don't need anything because there is plenty of light.

Both may, and probably will, be entirely wrong. Look for yourself. Have your exposure meter with you and actually check readings. If your readings indicate you have sufficient light, use that light and don't bother yourself with a lot of additional and unnecessary equipment. Let's look at a typical situation to see how you could handle it well.

The Crafts Group—Let's imagine that you have been asked to make a group photograph of a small group of ten people. They want a b&w photograph suitable for publication in a local newspaper. This group would be quite happy to pose outdoors in daylight for you, except that the only time it can get together is during the evening hours. And because the group is formed to pursue its common interest, candle making, it wants some of its products in the picture. Two 5x7 glossy prints are required and payment will be on delivery. Be there at 8:15 p.m., Thursday.

That's quite a bit of information. If you've gathered it all as you should, you have a good idea of what is required except how to make the picture itself.

At your earliest opportunity, go to the location where the group will assemble Thursday evening and inspect it. Be there as close to the appointed hour as possible so the lighting conditions will be similar to the time when you'll

make the photo. If the room has any windows, you can't get an accurate light reading during the daylight hours. Because this group is involved in a craft, it probably has a meeting area with good, even lighting. If not, the candles could come out looking a bit strange.

First, select a place where you can pose ten people. Look for a spot with a plain background where you can arrange those ten informally and comfortably. Because most rooms are set up to be functional rather than for photography, selecting the background may be difficult. Set up your camera and look carefully. One spot will always prove best, or at least the most inoffensive.

You now know where you want the group and have a general idea of how it will be posed. Check the exposure reading. I suggest you use an incident exposure meter. This way you are able to move around and measure the light over the entire area that will be occupied by the group. As you move about, be aware of any changes in light level. The meter should indicate an even light level within one exposure step over the entire scene. If it varies more than one step, reposition the camera so the group can be arranged in an area that does not exceed the light limit. I think you'll find that unless you are working in a very old building, the lighting will be from fluorescent fixtures. This kind of lighting is usually very even throughout the room.

If you don't have a hand-held exposure meter, you must use your camera's meter. Carefully study the scene through the viewfinder. Check the evenness of the light over the entire scene by looking from side to side. Any light fall-off at one side should appear obvious. If it does, reposition the camera.

Now check the entire scene with these questions in mind:

1 Enough space for the group to assemble and pose?

2 Even lighting throughout the scene?
3 Background clear of distracting elements?
4 Foreground uncluttered?
5 Clear area for photographer and tripod?
6 Proper choice of lens?
7 Exposure settings measured and recorded for later use?

BUSINESS ARRANGEMENTS

When working with groups, one of the most important points is to determine beforehand how the pictures are to be delivered and paid for. If you're photographing a group representing an organization, it will usually be a simple matter to determine who receives the prints when completed. It will probably be the person who contacted you. Also at that time, decide where you have to take the photograph, how many prints will be required, and who should be billed. This is the usual situation when dealing with small groups.

Larger groups, however, may require a different procedure. Often an individual representing a group will contact you and make the standard arrangements as to who, what, where and when, but will ask members of the group to handle orders on their own. Obviously, this means much more work for you because it's your responsibility to be sure each member finally receives his or her print and pays accordingly.

It's important to have some assistance in collecting names, addresses and payment at the same time. If the group is made up of people from out of town, and you don't get paid beforehand, you stand a good chance of mailing pictures to a few who will never get around to mailing you payment. Of course, you must keep your records straight so you know the prints you are mailing will get to the proper person. Once you've been paid in advance, it's your responsibility to deliver the goods. To be careless with names or addresses is inexcusable and leads to problems and delays.

10
Very Small Groups

Before you start photographing adult groups, I suggest you begin photographing very small groups of children. You'll learn a lot and no doubt make some good pictures too. Photo by Ted DiSante.

A very small group can be composed of one extremely large person or at least two regular-sized people. Very small groups are usually easy to photograph, but still present some problems.

A rule that holds true for groups of all sizes is that any problems encountered in photographing one person are multiplied by the number of people in the group. Remember the first time you asked someone to sit for a photograph? What problems did you have? Lighting? Posing? Expres-

sion? Blinking eyes? If you photograph a group of twenty people, all those concerns are multiplied by twenty—twenty sets of teeth and forty blinking eyes!

I consider a very small group to be two to five people. This is a pleasant-sized group because it is small enough for you to communicate easily with each person. You can be close enough to this group to give directions without screaming to be heard or having to use smoke signals. Working with a very small group allows you to be

inventive and creative. You can move it about and change locations freely without the danger of one member wandering away.

The group may be children from the same family, close friends from the neighborhood, or a rather elite set of people such as officers of a club, business corporation or religious organization. This can often be more awe-inspiring and intimidating to you than a large group including all of the rank-and-file members.

MAKING THE POINT

Nearly all photographs of small groups are made to record events such as who was elected, who won the prize, who attended, who had the smallest, or who had the largest. This is not unlike some newspaper photography.

Photojournalists, as newspaper photographers like to be known, are a capable bunch of people. Most are creative, interested and technically competent. But at certain times, their interest is somewhat lacking. Look at your hometown paper and pay particular attention to the group pictures.

For example, imagine a picture of three men seen from the waist up and grinning at the photographer. Above the picture in bold type reads *Father and Sons Set Record.* Cover the caption below the picture with your hand and contemplate what you see. Thousands of photographs are published each day around the world. A good percentage of them are totally inappropriate to the accompanying headline and caption.

When possible, put the group in an area that indicates the common purpose or accomplishment. This helps make the point and keeps the group relaxed in a familiar surrounding. Above photo by Diane Ensign-Caughey. Photo below by Sherry Ballou.

143

It's easy to *be* part of the very small group you are photographing. Use a wide-angle lens on the camera and hold the camera at arm's length while you take the picture. Photo by Forest McMullin.

Photographing very small groups of children can be particularly rewarding. Usually, they don't become overly self conscious or nervous about the shooting. This helps promote poses and expressions that are both natural and relaxed. Photo by Maron Meeks.

The point is that the picture can't begin to stand by itself. It tells who, but not what. Half of the information is lacking. Maybe this group grew the largest head of cabbage ever seen, but we'll have to accept that from the caption because we don't see it in the photograph.

Such a situation might happen because the photographer is required to record several small groups in a day, and after a while they all look alike. When time is short, imagination can also be short. Often a photograph will contain all of the necessary information, but will be unmercifully cropped by someone else. If this happens, you can only hope for better fortune next time.

The elements of an informative group photograph are not unlike

If the family has a common interest, such as bicycling, consider illustrating that interest in the family portrait. Photo by Diane Ensign-Caughey.

In this brother/sister photo a pleasant garden setting is an attractive location for an informal portrait. Photo by Diane Ensign-Caughey.

those found in a written report— who, what, where, when and why. The more of these elements you put in a group picture, the more interest you create in the viewer. As an example, think about the club Christmas party. *Who* is obvious because the group is posed so each face is clearly seen. The group dressed up and holding glasses tells *what*—it's a party. The background shows *where*, and the decorations say *when* and *why*.

Most people are proud to be in a particular group and will be pleased if the picture shows the group well. When asked to pose, a small group will almost always line up as if guided by some instinct. Explain your plan and give directions. The group will cooperate and appreciate your interest because, unconsciously perhaps, it is as tired of the shoulder-to-shoulder documentation as you probably are.

THE FAMILY PORTRAIT

One of the most common groups in this category is the family group. Family portraits have always been popular, and it's a rare photographer who is not asked to do one from time to time. Long ago it was desirable to place mom and dad on a pair of chairs and make the kids crowd around them as closely as possible. Sometimes one parent would stand and the other sit with as many kids on his or her lap as physically possible.

The style has changed and today people want to be individuals, while still part of a group. Poses tend to be more spread out and relaxed, enough so that each member of the group has his own area, yet close enough to hold the group together. Because of individual feelings of those in the family, you'll not be able to achieve the tightness you have with the social or business group.

This works to your advantage because a relaxed atmosphere always makes a more pleasing picture anyway.

Let's see what happens with the typical family portrait. The first decision will be whether the picture is taken indoors or out. Outdoors is usually easier if weather permits and if a suitable location is available. This is especially true if the family shares some outdoor interest, such as skiing, boating or tennis. Lacking some common interest, just being together in an attractive setting will suffice.

Arrange the pose in such a way that each person can stand, lean, sit or otherwise achieve a relaxed position away from distracting backgrounds. One of the most static arrangements you can devise is placing the group so all heads are at the same level. Small groups allow you the flexibility of placing individuals in different positions

When working outdoors in bright sun, consider using the sun as a source of back light. Make the exposure reading from the front of the subjects. This will cause the background and portions of the hair to be overexposed, but in most cases it yields a good picture. Photo by Diane Ensign-Caughey.

for the desired composition. Once the location is chosen, let the group arrange itself, with only slight direction, while you study the parts. After the preliminary pose is made, make an exposure or two. After a couple of exposures, the group will relax a bit and you can begin to adjust the composition. After each change, make a few more exposures. After shooting a roll or two this way, you'll have a nice variety of poses. **Outdoors**—When working outdoors, look for a location similar to that used for the outdoor bridal portrait discussed in the wedding section of this book. This is the nice, shady spot where no one has to squint at the sun, and you don't

If you make outdoor group portraits under cloudy skies, you don't need any extra lighting equipment or special tricks. Photo by Forest McMullin.

have to deal with harsh shadows. If you need fill light, the reflector won't be of much value here, though, because it takes a very large one to provide enough light to cover the whole group. In this case, I recommend that you use the flash-fill method described earlier.

Indoors—Here, you are faced with problems of location and light. Location may prove a difficult choice, depending on the size of both the home and the family. The living room or family room will work, usually, even if some furniture needs to be moved. Other spots that may be appealing are near an especially attractive window or fireplace. Before you begin to arrange equipment or the pose, take time to thoroughly scout all possible picture locations.

Discuss beforehand what the group will wear. The family's lifestyle will generally dictate how they dress. A very relaxed group will look ill at ease if put in suits and evening gowns. The term *formal portrait* refers to the style in which the picture is posed and lit. The manner of dress may be extremely casual. After all, nudists have family portraits too.

One Final Tip—Not much control is required on your part when working with most family groups, but use the amount of control you need. Small children can be a problem, so you should enlist the aid of mom or dad. But don't place all the work on them. They want to appear as comfortable as possible and worrying about themselves *and* their small children is difficult. You must assume some of the responsibility of controlling kids by keeping their interest. It's part of the job. If you can't, or won't do it, avoid this kind of job and stick with adult groups. It takes a special type of person to get the best from children, whether they are alone or in a group.

Using a simple, on-camera flash to photograph a very small group may be the simplest solution to poor indoor light. Photo by Forest McMullin.

11
Small Groups

Photo by Steve Shay.

Moving on from the very small group, we come to the small group. This group is larger than very small, but still doesn't qualify as large. In my opinion, six to twelve people make a small group. This group is still fairly easy to control, and you may approach it with confidence. It is not so large that you can't communicate with its members directly from a reasonable distance.

However, even a small group can begin talking to itself and blinking its eyes if you don't keep control. You must direct the pose and expression and catch its attention at the moment of exposure.

Generally, the larger the group, the less patience it has and the less time you have for the photo session. Often, this means arranging the simplest pose and making a few exposures quickly. This is what happened when I made this photo. In retrospect, however, I should have taken the necessary time to use flash fill to open facial shadows.

HOW NOT TO DO IT

Recently I had an experience that was a good lesson. It shows that even if you know all this stuff, finding yourself on the other side of the lens can sometimes be a helpful refresher course.

I'm involved with some people who volunteer time and experience helping young people of high-school age become acquainted with the business world.

Prior to working with the students, the volunteers are given several training sessions. The organization had contracted with an agency to produce a newspaper ad with photo to promote public awareness of our aim in the community. The photograph was to be taken at one of the training sessions and those of us who by chance had arrived in coats and ties were selected to form the group for the ad photo.

Two photographers were on hand. They explained their plan and showed us the layout artist's sketch. They then posed us . . . and posed us . . . and posed us. What should have been a five-minute job went on for nearly twenty minutes.

The result was that when I saw the published photograph, I had the feeling I was viewing a group that had little real interest in its purpose.

This happened for a number of reasons. The group had no previous warning that the photograph was to be taken. In addition, we were composed of individuals, selected at random, who had arrived at the meeting site for an altogether different purpose than to pose for a photograph.

The time spent posing the group seemed excessive to me, and the direct communication from the photographers was less than minimal. Staring silently at the group while mentally rearranging a pose does not relax a group. I found myself staring back and mentally rearranging the pose of the two photographers to such a degree than when their direction finally did come, I didn't hear it.

149

Schoolchildren also have a habit of arranging a pose all by themselves. Typically, they will line up in rows and smile on cue. Photo by Ted DiSante.

HOW TO DO IT

You can go a long way toward avoiding these problems by following some simple guidelines:

Be Prepared—Have a clear idea of the photo you want before you photograph the group.

Be a Nice Person—Talk with the group and be interested in what you're doing together.

Give Direction—Let the group know what you want and what it should do for you.

Work Quickly and Smoothly—Don't stand and stare while you try to figure an arrangement. You have a plan, so move into it immediately and begin to photograph. Change the pose as you go along.

Direct While Looking Through the Viewfinder—This is really quite important. The film sees what the lens sees. If you look through the lens you will see it too. Many times I've seen a photographer put the camera on a tripod before a group and then run from side to side, arranging the pose. When it looks good, he trips the shutter by cable release from six feet away. The group might look terrific from where the photographer is standing, but the film *might* see the group of eight people with only seven heads.

POSING

To help you in posing a small group, you want to know a few things beforehand: WHO—You may not want to photograph this group; WHY—It can make a difference in what you decide to charge; WHERE—You have to find the group; WHEN—It helps if photographer and photographees are there at the same time.

Now you can begin to plan the pose in your mind. Perhaps your first idea is not perfect, but it is a good place to begin. Between this first vision and the first click of the shutter, you will have refined the pose in your mind so you can approach the group with a clear plan. Arrange the group according to that plan and begin. As you work, communicate with the group. Direct its movement and

Often, the group will automatically strike its own pose without any guidance from you. If this happens, use the opportunity to make an informal and relaxed picture. This is what George Kew did with this group of young actors.

expression. Warn it before you make an exposure so it can keep its eyes open and its attention alive.

Be as brief as possible. A group isn't like a puppy that will play for hours. A group tires easily and becomes restless. That's especially true if the photo session is during a break in another activity. For example, I often photograph groups of doctors who are speakers at medical meetings. I usually photograph them during a coffee break in the program. Trying to control the group for more than five minutes during a short coffee break will probably not get me asked to do the pictures next year.

If you are going to photograph a group under similar circumstances, arrange to work with the group before it gets to the coffee pot. With cups in hand, a group can be too at ease for you to direct effectively.

When I discussed a very small group, I suggested that you arrange the members so the viewer of the photograph could easily recognize the reason for the picture. I also recommended that you show some action or demonstrate the common interest. However, the larger the group, the more difficult this approach may become.

The lighting, posing, and expressions of this group are all fine. The problem is that only two of the eleven people have eye contact with the viewer of the photograph. Try to avoid this. Photo by George Kew.

BE CREATIVE

Over the past few years I have photographed groups of graduating laboratory students. There are usually ten or so students in these small groups. In the beginning I worked with the group immediately following the graduation ceremony, which was held in an auditorium. The plan was to arrange the members in two rows against a bare wall. On command, they would stand straight and smile as I made the exposure. The lighting was one electronic flash on each side of the camera.

The negatives were always well exposed, sharply focused, and composed well enough. I made enough exposures to insure that at least one negative would be available with all eyes open and all heads forward. The pictures were always satisfactory, salable images. The only problem was that they were boring for me. No one else ever complained, but they were just not any fun for me to do.

One day I decided that I was not going to do the same thing the same way from that point on. I decided I would schedule the next group outside in a park and try to create a casual, relaxed atmosphere following the graduation luncheon. The classes were over, the program formalities were over, and the group was prepared to relax. The scene included a picnic table under a tree, and the members, with very little direction from me, positioned themselves against the tree, on the table and on the grass. The session was quick and simple, and the resulting photographs were splendid.

Try different poses and group arrangements. Of course, the limits to what you should try depend on the group. Diane Ensign-Caughey had no problem posing the children differently for the above photo.
For the bottom photo, the artist and his work are centered in the photo with an admiring group surrounding him. Photo by George Kew.

152

12
Large Groups

Photographing large groups such as this one can be rewarding both socially *and* financially. Photo by Mary Goschnick.

A large group is composed of a dozen to a hundred or more people. A large group can form for a number of reasons, such as national or regional meetings, educational classes or seminars, civic or social organizing or other business-related activities. A large group seems to be hungrier than small groups and often wishes to be photographed at its banquet.

Fortunately, few of us are called upon to photograph large groups. I don't mean to scare you about a large group, only terrify you. I don't want any letters saying you followed my directions and the group still tried to lynch you. My directions are no substitute for experience on your part.

Don't work with a large group until you have satisfied the requests of several very small or small groups. If through some miscalculation you made poor pictures of a small group, you may be lucky or persuasive enough to get the group to pose again. A large group, however, is like a wedding—if you blow the job, the group will not get together again for your convenience. A flop with a large group not only puts a heavy dent in the reputation you might be trying to build, but can result in the loss of money.

There is an obvious physical problem with a large group. It won't fit nicely into an attractive corner of a meeting room. It may not fit comfortably into an entire meeting room. Of course, the larger the group, the larger the area needed to photograph it satisfactorily.

Specialists have the necessary lights, large-format camera, step ladder, and personality to make the photograph in practically any surrounding. I advise the rest of you to work outdoors, if even remotely possible. This is usually easily arranged, weather permitting, and it is your first step toward success. Unfortunately, many large groups are at meetings held in the fall or winter months, when many areas have terrible weather.

CONTROL

You, as the photographer, must be in control of any size group, but you must be especially demanding of the large group. With the smaller groups you can work in a relatively relaxed, informal manner, but you must *dominate* the large group. You are the star of the show. If you are not, the group will get out of hand very quickly.

You must be prepared beforehand. Select the location, arrange equipment, direct the group into position, hold its attention, make the necessary exposures, and thank the group as if it were one smooth motion.

How Not to Do It—I once watched a photographer work with a group of about 60 people. He arrived at the meeting site, announced his presence, and directed the group to follow him to the site for the picture. The problem was that he hadn't checked ahead and determined the site he wanted. He and the group wandered for 30 minutes around an area of about three blocks in the center of a large city, trying to locate an ideal site. When he found the site, the group was down to less than 45 people. Then he began to unpack equipment, select a camera angle, set up the tripod, and make exposure readings.

When he arrived at the meeting a full hour earlier, he had the group's attention. Now not only had he lost its attention, he had to make a picture of only 38 people, a small percentage of the original group. As a result, his sales were minimal, his reputation was blemished, and he was not asked to photograph that group the next year.

I did not invent this story to prove a point. I know the man and know him to be a serious, competent photographer. The problem is that he is extremely competent in other fields of photography, so he expected to handle the situation without planning. He expected the group to be in awe of his reputation, follow him anywhere, and await his directions. Unfortunately for him, that wasn't the case.

Taking Control—You must pose the group in some reasonable order. It must be one group focusing its attention on you, the director. With a group of twenty or so, the pose may still be relatively casual, with some members sitting, some standing or some leaning. But the composition must be tighter than that of the smaller group. Because each person naturally wants to be recognizable, the larger the head size in the resulting photo, the better. Consequently, the tighter the grouping, the better.

Photographing a large group of children requires an incredible amount of control—sometimes so much that you'll never be able to get them to hold still for a few exposures. Photographer Gary G. Morris used flash to freeze subject motion. The result is not a great group photo, but it does capture the mood of the scene. Photo courtesy of the City of Tucson Office of Community Relations.

A group of a hundred or more allows little, if any, creativity in composition. The object is to get the group lined up, closed up and standing up, so each person can see and be seen. That demands that either each row be placed at a higher level with respect to the row in front of it, or the camera angle be high enough to make the necessary separation. The steps of a large building, the bleachers of a sports center, or the side of a hill in a park are all reasonable locations for the standard group arrangement.

When you speak to an individual, you normally look into his or her eyes, which are more or less in the center of the head. Therefore, it is natural when working with a group to focus attention on the center. However the people in the center of a large group are restricted by their location and require less attention than the people on the ends. These people, basking in the glory of relative freedom of movement, require watching. If left to their own devices, they tend to wander away. Keep them in line by demanding their attention and working as rapidly as possible. If people wander off to the shade of a tree, they won't appear in the picture and won't buy the print. If an end breaks away, that makes the next part in line an end, and so on.

CAMERA ANGLE

The best camera angle for photographing large groups comes under the classification I call *low-altitude aerial photography*. And the large group, or the group posed on a level surface, requires the highest camera position so all members can be seen in the print.

Depth of field is an additional problem in photographing large groups. The larger the group, the greater the problem. Obviously, you don't want the front row clear and sharp and the last row blurred and fuzzy. The higher the camera position, the greater the chance of even focus, front-to-back.

If you must climb on something to make a photograph from a high angle, make sure it's safe. Don't climb something that you are not sure will hold your weight and equipment. Check above and see that you are not climbing into an overhead wire, light branches or other obstacles. Have an assistant below you to steady your support and hand you items you need.

This is a typical arrangement of a large group on the steps of a building. This allows every head to be clearly seen and photographed. Also note that even though photographer George Kew was working with direct midday sun, facial shadows are not a problem. He solved that problem with careful site selection—the concrete area in front of the group acts as a reflector and fills in shadows.

HOW WE PHOTOGRAPH SUMMERTIME GROUPS
by Mary and Bill Goschnick

Each summer we look forward to attending class reunions—not our own, but gatherings we can photograph. We have been taking group pictures at class reunions for 20 years because it is an unusual and enjoyable way to expand our business.

THE CONTACT

When we read the local paper, we note any ads or articles describing upcoming class reunions. We call the person in charge and ask if a photographer has been hired for the reunion. Most of them say their budget does not allow for one. We explain that we do not charge for a "sitting fee." We just sell the group portraits to individual members. This no-obligation approach usually interests smart committee chairmen.

We talk over our plans and needs with the person in charge before we go to the reunion because he can be very helpful. We have him prepare a sign to be included in the photograph, announcing the class year, high school, and which anniversary the group is celebrating. The chairman can help organize and line up class members when it's time to take the picture.

We ask how many are expected to attend the reunion—usually between 25 and 150—and emphasize

that we only photograph class members, not their spouses. We schedule the picture right before dinner, usually between 6:30 and 7:30, which makes it early dusk in the summer. We arrive about half an hour early to choose our site.

CHOOSING THE SITE

When possible, we prefer to take the pictures outside. We look for small hills, or buildings with steps, so we can line people up in ascending rows. If it is raining, or if we have to work indoors, we have to be a little more innovative when

lining up people. We use bandstand risers before dance musicians arrive. Sometimes we temporarily rearrange food tables and chairs. During the initial phone call to the chairman, we always reserve the right to turn down an assignment if a hall is too crowded or impossible to photograph. But this has never happened.

ARRANGING PEOPLE

Indoors or out, we arrange people the same way. Class officers and members of the reunion committee are seated in chairs in the front row. Women in bright dresses stand in the first row behind the chairs, and others are lined behind them in rows. We ask those standing on the left and right to turn toward the center, so more people can fit into one row.

We use a medium-format camera on a tripod and Vericolor II Type S film for our reunion photographs. We make three or four exposures to insure getting at least one good one with all eyes open.

BUSINESS MATTERS

While everyone is still standing in a close and attentive group, we use a megaphone to explain how to order photographs. We collect money once everyone is seated at the dinner table.

We offer 8x10 photos for $6 and 11x14 portraits for $9. Both sizes are in color. We go to each table

with clasp envelopes—8x10 and 11x14 sizes. The customers choose which size photo they want and take an envelope. We tell them to self-address the envelope and put the money inside, but not to glue it shut. We make sure to bring plenty of pens and $1 bills to make it easy for them to order and pay.

We have found that the longer a customer has been away from school, the more likely he is to buy a class reunion photograph. At 50-year reunions, over 95% buy the portraits. At 30-year reunions, 60% buy. Sometimes, fewer than half will buy at 10-year reunions.

We promise delivery in about three weeks. Occasionally we personally deliver local orders. When we mail the packages, we pad the envelopes with cardboard. First class postage is about forty-four cents for the 8x10 packages, and fifty-three cents for the larger envelopes, which we send third class. Postage and material costs are included in the print prices.

VARIATIONS

Once you realize how easy class reunion photographs are, you may want to try a related enterprise—family reunion portraits. We have approached groups in local parks on Sunday afternoons and offered to take their portraits. We always carry along samples of photo-

graphs we have taken for other reunions—this lets people know we have done similar work and can offer a good product. Because we choose local parks, someone in the group usually knows us and can vouch for our reliability.

If the family reunions are comprised of several smaller families, we usually take one large group photograph first, and then photograph individual families separately. At class reunions, we cannot take pictures of couples or smaller groups because we don't have the

time or manpower to collect and separate payment envelopes. We enjoy extending this service to families, though.

Reunion pictures are not always onetime assignments. We have had families and committee chairmen call us to say we photographed them a few years ago and they would like us to photograph their next reunions. We always say: "Of course—we'd be delighted."

Reprinted with permission from *The Professional Photographer*, Copyright 1980 PPA Publications and Events, Inc.

CONVENTIONS, REUNIONS AND PARTIES

More non-professional than professional photographers are asked to handle these jobs, primarily because the host committee makes every effort to cut costs.

If you are the amateur, this doesn't necessarily mean that they think you are worth less than a professional, but they do know you'll work cheaper. In addition, you'll usually be photographing small groups within the large group. Before jumping in with an offer to work for next to nothing, be sure you know what is ahead.

Convention and reunion photography are very demanding. You will be asked to photograph groups of all sizes and in all situations and locations at all times. This means having enough time and film; proper cameras and lenses; adequate lights and the ability to move from meeting room A to cocktail lounge B to auditorium C. If you've followed this book faithfully to this point, you should have no trouble with the small and very small groups. Always ask beforehand whether or not you are required to do a large group.

Some Logistics—One of the most common demands of conventions is that you have the day's and evening's photographs processed and enlarged as proofs and on display in the lobby of the convention site the next morning. This gives everyone a chance to see what you did and to place their orders. Unless you have a good arrangement with a good local commercial lab, you need your own darkroom facilities.

Perhaps it's a short convention and you can do it yourself. How much sleep do you really need for four days and three nights anyway? Remember that you need someone to take orders from the proofs each day while you are taking more photographs. If you've considered the time and materials necessary and have priced your work accordingly, you can make a fine profit. If your work is good,

you'll be asked to do such work often. However, don't become too smug because if you do it too often, people will consider you a professional and begin looking for a less-expensive non-professional!

There is a further complication when doing reunion or party pictures. You must not only keep track of who wants the picture and where to send it, but which picture to send as well. Suppose you are asked to photograph couples and other groups at a large dance. If you are not careful, it can be a difficult job. Set your equipment in a location with a pleasing background and stay there. Let the

Regardless of how late you worked the night before, numbered proofs must be ready prior to the first event of the next morning. You can't sell what you can't show.

When you work a convention, be sure to photograph all featured speakers and the board of directors of the organization.

group come to you; don't chase around looking for it. Keep the camera on a tripod so all of the exposures will be basically the same.

Before you make each picture, get names, addresses and payment. Also record the roll and frame numbers of the photos you make of each person or group. Be sure you are right because you don't want to send the wrong photos to the wrong people. An assistant is always a great help in recording this kind of information. The reason you are there is to make photographs. An assistant allows you to concentrate on that task.

How Not To Do It—A few months ago I attended my high school class reunion. It was a large affair of about 400 people, and as usual a local studio was contracted to photograph people. It was a simple arrangement for the one photographer and his assistant.

However, the first thing they did was sit down to cocktails and dinner. Following that they rested awhile and eventually set up equipment near the bar, the most congested spot in the room. By then, the party was in high gear and a line quickly formed around them because everyone wanted to be photographed with old classmates.

The result was disastrous. The background was formed by the line of people at the bar, and because of the crowded location the photographer had no idea who was really supposed to be in each picture. The assistant quickly managed to lose track of who had paid, who was in each picture, and which pictures were to be mailed where.

This was not very satisfactory to the people who paid and never received their pictures. The studio owner wasn't pleased with the comments that followed later, either. Of course, the mistake the photographer and his assistant made was to make the affair *their* party instead of a job. If you go to work, then work.

Index

A-3.819805859